DRAWING WORKBOOKS
TREES AND PLANTS

Bruce Robertson

NORTH
LIGHT
BOOKS

Cincinnati, Ohio

Dedication
To Frank Wood –
unique art teacher

Acknowledgement
Many of the drawings are by students or members of
the Diagram Group. Wherever possible they have
been acknowledged in the captions. The following
are acknowledgements to libraries and museums who
own the works of famous artists.
p27 Cesare da Sesto: Royal Library, Windsor Castle, England
p55 Vincent Van Gogh: Art Institute of Chicago, Chicago
p64 Albrecht Dürer: Graphische Sammlung Albertina, Vienna

Artists
Joe Bonello
Alastair Burnside
Alison Chapman
Richard Czapnik
Brian Hewson
Richard Hummerstone
Lee Lawrence
Paul McCauley
Kathleen Percy
Jane Robertson
Graham Rosewarne
Guy S. R. Ryman
Ivy Smith
Mik Williams
Robin Williams
Martin Woodward

Typographer
Philip Patenall

Editors
Carole Dease
Damian Grint
Denis Kennedy

Cover illustration by
Philip Patenall

© Diagram Visual Information Ltd 1987

First published in Great Britain in 1987
by Macdonald & Co (Publishers) Ltd
London & Sydney

ISBN 0-89134-228-1

Published and distributed in the United States by North
Light Books, an imprint of F&W Publications, 1507 Dana
Ave., Cincinnati, OH 45207

The publishers have made all possible efforts to contact the copyright
owners of the illustrations reproduced, but apologize in advance for
any omissions from the above Acknowledgement.

DRAWING WORKBOOKS

THIS BOOK IS WRITTEN TO BE USED.
It is not meant to be simply read and enjoyed. Like a course in physical exercises, or any study area, YOU MUST CARRY OUT THE TASKS TO GAIN BENEFIT FROM THE INSTRUCTIONS.

1. READ THE BOOK THROUGH ONCE.
2. BEGIN AGAIN, READING TWO PAGES AT A TIME AND CARRY OUT THE TASKS SET BEFORE YOU GO ONTO THE NEXT TWO PAGES.
3. REVIEW EACH CHAPTER BY RE-EXAMINING YOUR PREVIOUS RESULTS AND CARRYING OUT THE REVIEW TASKS.
4. COLLECT ALL YOUR WORK AND STORE IT IN A PORTFOLIO, HAVING WRITTEN IN PENCIL THE DATE WHEN YOU DID THE DRAWINGS.

Do not rush the tasks. Time spent studying is an investment for which the returns are well rewarded.

LEARNING HOW TO DO THE TASKS IS NOT THE OBJECT OF THE BOOK, IT IS TO LEARN TO DRAW, BY PRACTICING THE TASKS.

WORKBOOKS ARE:
1. A program of art instruction.
2. A practical account of understanding what you see when you draw.
3. Like a language course, the success of your efforts depends upon HOW MUCH YOU PUT IN.
YOU DO THE WORK.

● Drawing is magical, it captures and holds your view of the world. Once produced, the drawing is eternal: it says 'This is how I see the world at this place in this time.' It tells of your abilities and your circumstances.
● Drawing is a self-renewing means of discovering the world, and its practice is self-instructive. You learn as you go along and you improve with practice.
● Drawing is a universal language understood by everyone. It is also a concise and economical way of expressing reality and ideas.
● Drawing is a state of consciousness. You lose yourself in the drawing as you become involved in your responses to what you see. It has a calming effect when you feel depressed, agitated, ill or dissatisfied. You are outside yourself. Everyone can learn to draw. Be patient and try hard to master the skills.

TOPIC FINDER

Drawing TREES AND PLANTS

Mastering plant drawing is not a simple skill. The qualities that make up a living plant are elusive. Drawings over which you spend a great deal of time may be accurate but lack life. Drawings done quickly after much practice may capture the very essence of the plant.

You will learn to produce a successful drawing by the combination of three factors: understanding what you see; mastering your tools; and seeing your drawing as an expression of a unique statement, independent of the original.

Plant drawing is not copying nature, it is describing it.

Work your way slowly through this book. It is designed to help you achieve success with your work.

Learn to observe — look and see the particular features of plants and trees. Then you must understand what you see, building up the knowledge that reality has features that you must use to help you capture and describe its qualities. Often a beginner is inhibited because of a lack of experience with tools. Particular brushes and pens prove difficult to work with confidently for the first time. Mastering your tools will give you that confidence.

Gradually that most important aspect of plant study will unfold itself to you — its potential for producing wonderful inspiration for decorative motifs.

One certain way to develop your skill is to work carefully and slowly. Spend a long time on a study. Later drawings can be produced quickly, or with unfamiliar tools. Confidence comes with practice. You learn as you draw. Earlier drawings always reveal the innocence of your experience — the part you feel most unsure of. When you have developed the mastery of drawing, and the confidence of skill, this quality of innocence is the very element you should retain when trying to create a fresh and lively study.

CONTENTS

Chapter One LOOKING AND SEEING

Chapter Two UNDERSTANDING WHAT YOU SEE

Chapter Three MASTERING TOOLS

Chapter Four CONSIDERING DESIGN

CHECKING YOUR PROGRESS

You may not do all the tasks in the order they appear in the book. Some require you to research sources of photographs or other artists' works, some direct you to museums and art galleries, and some may be done quickly while others can only be completed when you can devote more time to their study.

To help you keep a record of your completed Tasks, fill in the date against each numbered Task in the space given beside it.

TASK 1	TASK 31	TASK 61	TASK 91	TASK 121
TASK 2	TASK 32	TASK 62	TASK 92	
TASK 3	TASK 33	TASK 63	TASK 93	
TASK 4	TASK 34	TASK 64	TASK 94	
TASK 5	TASK 35	TASK 65	TASK 95	
TASK 6	TASK 36	TASK 66	TASK 96	
TASK 7	TASK 37	TASK 67	TASK 97	
TASK 8	TASK 38	TASK 68	TASK 98	
TASK 9	TASK 39	TASK 69	TASK 99	
TASK 10	TASK 40	TASK 70	TASK 100	
TASK 11	TASK 41	TASK 71	TASK 101	
TASK 12	TASK 42	TASK 72	TASK 102	
TASK 13	TASK 43	TASK 73	TASK 103	
TASK 14	TASK 44	TASK 74	TASK 104	
TASK 15	TASK 45	TASK 75	TASK 105	
TASK 16	TASK 46	TASK 76	TASK 106	
TASK 17	TASK 47	TASK 77	TASK 107	
TASK 18	TASK 48	TASK 78	TASK 108	
TASK 19	TASK 49	TASK 79	TASK 109	
TASK 20	TASK 50	TASK 80	TASK 110	
TASK 21	TASK 51	TASK 81	TASK 111	
TASK 22	TASK 52	TASK 82	TASK 112	
TASK 23	TASK 53	TASK 83	TASK 113	
TASK 24	TASK 54	TASK 84	TASK 114	
TASK 25	TASK 55	TASK 85	TASK 115	
TASK 26	TASK 56	TASK 86	TASK 116	
TASK 27	TASK 57	TASK 87	TASK 117	
TASK 28	TASK 58	TASK 88	TASK 118	
TASK 29	TASK 59	TASK 89	TASK 119	
TASK 30	TASK 60	TASK 90	TASK 120	

LOOKING AND SEEING

Before you begin your drawing Tasks, Chapter one invites you to look more closely at plants or the landscape, and to study what you see.

Natural forms are notoriously hard to draw because they often appear to present a tangle of shapes and forms.

Your earlier results will be very dependent upon your powers of observation. There are thirty-two Tasks to sharpen your judgement of what you see.

● The first two pages, 6 and 7, contain the most important idea in the book: places recede from you and contain solid objects – but you have only a two-dimensional surface on which to record them.
● Pages 8 to 11 help you check what you see and not to rely upon imagined shapes. They encourage you to examine the solid elements and the spaces between the parts.
● Pages 12 and 13 explain that all natural forms have a three-dimensional quality: they protrude from or recede into the picture.

● Pages 14 to 17 direct your attention to the surface qualities of trees and plants, their color, their shading, their individual and collective textures.
● Pages 18 and 19 show examples of the vast range of natural forms and the way each unique species can be interpreted to add interest to your drawings.
● The review, page 20, has examples of the way artists have looked at nature and how their view influences their drawing.

6 Solid or flat

Drawings are flat objects, a surface with marks. The two-dimensional limitations must be overcome when trying to capture the three-dimensional reality of a plant or tree. Your drawing should attempt to describe the real world's features. Plants consist of shapes, tones, forms, textures and colors. Each of these characteristics can vary depending on your position and the conditions in which you view them. When drawing a subject from one view try to remember what it looks like from other points of view.

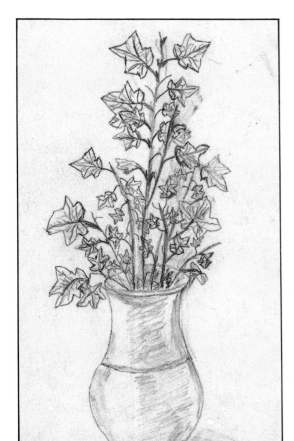

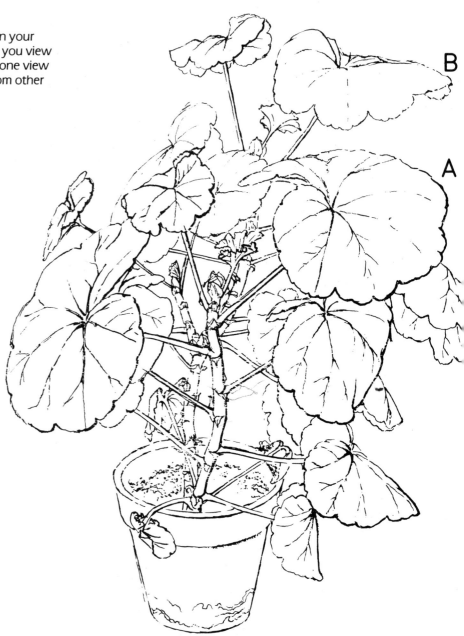

B

A

Granny's plant study
Left, the first-ever drawing of a plant by Granny, aged 76. Beginners see leaves, flowers and vases as flat shapes. When they draw subjects, they draw a net of lines with little regard for the spatial properties of the object.

TASK 1
Recording reality
Draw a bunch of flowers in a vase, or a small household plant. Take a long time over your drawing and record the maximum amount of detail. Pencils are usually best for beginners, but you can try any drawing implement.

Kathy's plant study
Right, a mature student's drawing of a plant. Education has taught her to vary line thickness to indicate changes of direction, to observe very carefully the details, and to consider the three-dimensional reality of the plant.

TASK 2

Caged space

Another way to realize the space of plants is to imagine them in a cage. On a tracing paper overlay, draw a wire cage over Kathy's plant, left. Make the cage like a box with vertical sides and horizontal top.

TASK 3

Drawing plants

Place the plant or bunch of flowers you sketched in Task 1 on the floor and do another drawing of it viewed from directly above. Identify on this drawing the same leaves as in Task 1. Also, can you identify the leaves **A** and **B** (left) on Kathy's plan view (above)? The answer is on page 29.

Seeing space

Edges are the forms of objects seen side on. Even the thinnest of leaves has thickness. Each plant has its own characteristic type of leaf and, although the individual leaves appear to you to be different, this is often because you see them twisted or turned.

©DIAGRAM

TASK 4

Seeing Space

Do a plan drawing of the plant (above). Remember, each leaf is of similar shape, each leaf points away from the center, and each leaf may be directly above or below.

8 Checking what you see

Checking helps with accuracy. Take care to record the vertical, horizontal, and recessive relationships of fixed points on your plant study. The two-dimensional relationship is drawn vertically with a plumb-line and horizontally with a held-out pencil. Recessive relationships require you to maintain the same position throughout the study.

Recessive checking
You observe objects with two eyes – you are bifocal. This means that you see two images that are superimposed by your brain to produce an impression of a solid world.
You see a little of the opposite sides of objects close to you and again because you are bifocal, objects set in space have a displacement relationship between two points in space. Check this in Task 6

TASK 6
Checking displacement
Sit with your head resting on a fixed point, and view two objects, one in front of the other, with one eye only. Mark a point on the first object which is in line with a point on the second. Close the first eye and repeat, and you will find that the point on the far object is different.

TASK 5
Framing your view
One simple method of checking the vertical and horizontal alignments of points is to make a frame through which you view the plant. Cut two L-shaped pieces of card and clip them together to form a frame. Check off the points which touch the edges in your view with similar points on your drawing.

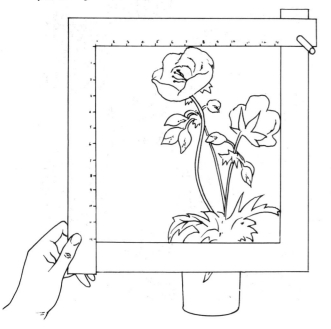

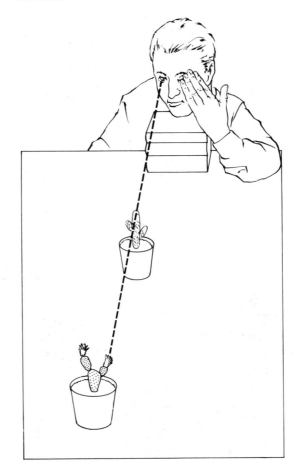

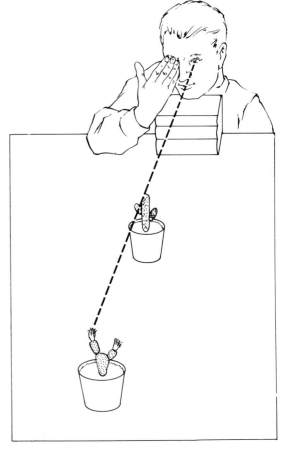

Vertical checking
This is achieved by holding a weighted line in front of the plant, sighted so that higher points can be checked against positions lower on the plant. Horizontal points can be sighted by viewing them across the edge of a pencil held at arm's length.

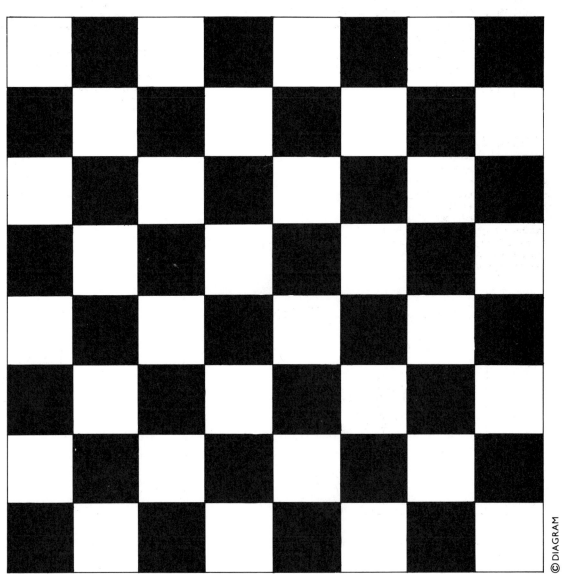

TASK 7
Vertical alignment
Make a hanging line from string or thread attached to a key. Fix two points, one above the other, on your plant study, and check them with your earlier drawing.

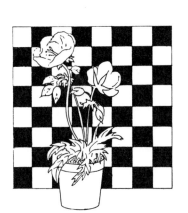

TASK 8
Horizontal checking
Place a plant in front of a checkerboard and draw the shapes carefully with a soft pencil on tracing paper placed over this grid (right). Pay particular attention to the places where the branches cross the dark squares and make sure your drawing records these points.

Often beginners are worried about their ability to draw accurately the complex and unique shapes of plants. Every plant seems different and there are no simple relationships between the parts. One method is to examine very carefully the shapes plants make, and the shapes of the space they leave exposed.

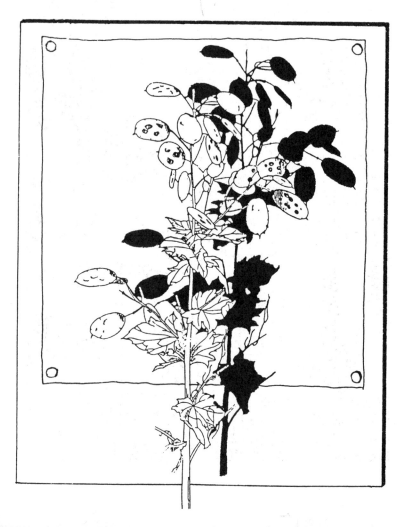

TASK 9
Helpful surroundings
When studying small plants, it is helpful to stand them in front of brickwork or trellis where the verticals and horizontals can be used to check their shapes.

Shadow shapes
Right, the complex shapes can be more easily recorded if you think of them as silhouettes, or shadows of the forms. This drawing by Jane, aged 12, was made by inking in the shadows, cast on to paper, of a garden plant.

TASK 10
Shadow shapes
Pin a sheet of white paper against a vertical surface, then stand a plant in front of it. Shine a single light source at the plant and then record the resulting shadows. Another method is to take a white board into a sunny garden, stand it behind a plant, and then record the shadows in your notebook.

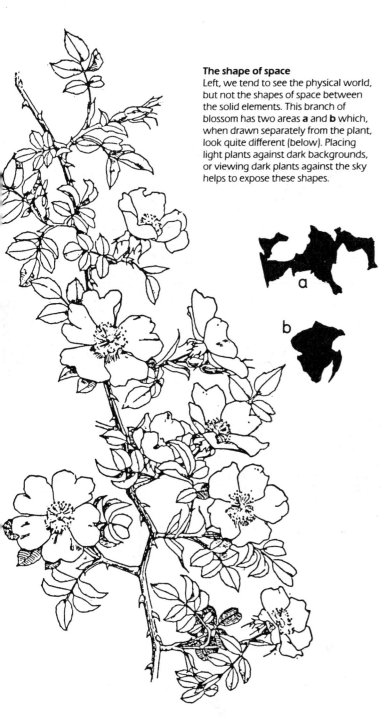

The shape of space
Left, we tend to see the physical world, but not the shapes of space between the solid elements. This branch of blossom has two areas **a** and **b** which, when drawn separately from the plant, look quite different (below). Placing light plants against dark backgrounds, or viewing dark plants against the sky helps to expose these shapes.

Shapes in space
Right, each shape seen through branches is not bordered by sides which are touching one another. You are not looking at holes in a flat net of lines. They are the result of your position as much as the position of each to the other. The two shapes (**A** and **B**) are the consequence of crossing boughs which are spread well apart in the picture space. They belong to branches on trees about 10 ft (3m) apart.

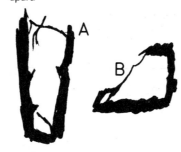

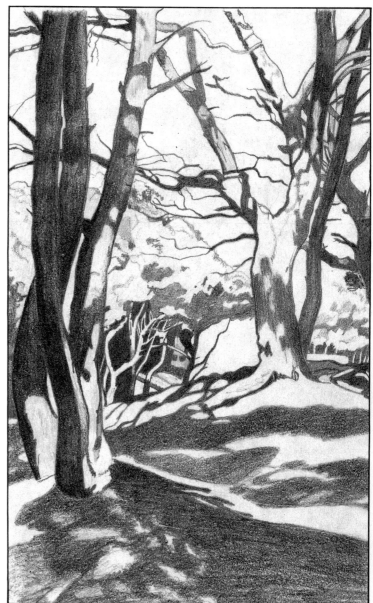

TASK 11
Shape of space
Place tracing paper over photographs or drawings of plants and fill in with a felt-tipped pen the spaces between the foilage. Try this exercise on the drawings on pages 27 or 29, or do a drawing looking at the sky through a group of branches.

TASK 12
Changing shapes
Select a simple open tree or bush and draw the space between each group of branches on one part of the tree. Move your position to view the subject from another side and draw the same area, not the changing shapes.

Each end of a branch is located within the three-dimensional space of the tree. Linear subjects may look flat, but their open cage-like qualities are easily revealed if you walk around them and notice the changing relationships.

Transferring points
Right, keep your viewing position constant while you study a subject. This will help you to record the relationships accurately. Sit so that you can directly transfer your vision of the object on to paper (**A**) rather than turning your head through a wide arc (**B**).

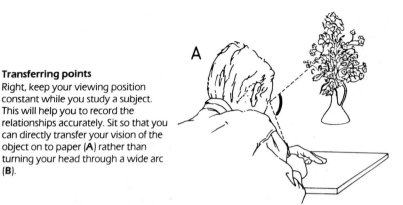

A

B

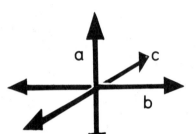

Spatial points
Left, branches reach out in three dimensions.
a. Upward and downward
b. Sideward from left to right
c. Inward and outward.
The end of branch at **c** may appear above a point at **c** but in fact is much deeper into the picture.

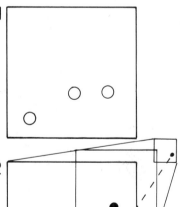

The Stars
Left below, the deceptive relationship is best illustrated by considering the stars in the sky. Each may appear to be alongside or above others (**1**), but within the vast depth of space they are often light years away from each other (**2**).

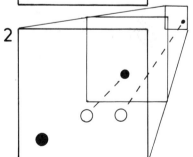

TASK 13
Radial points
Do a study of a tree that has fallen down so you can look down the central trunk and record the radial arms of the branches. Another way to study this effect is to draw a plant from a position above the top and looking down onto the group.

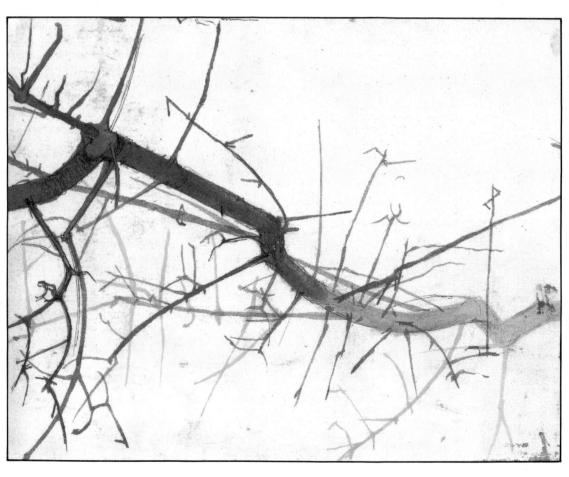

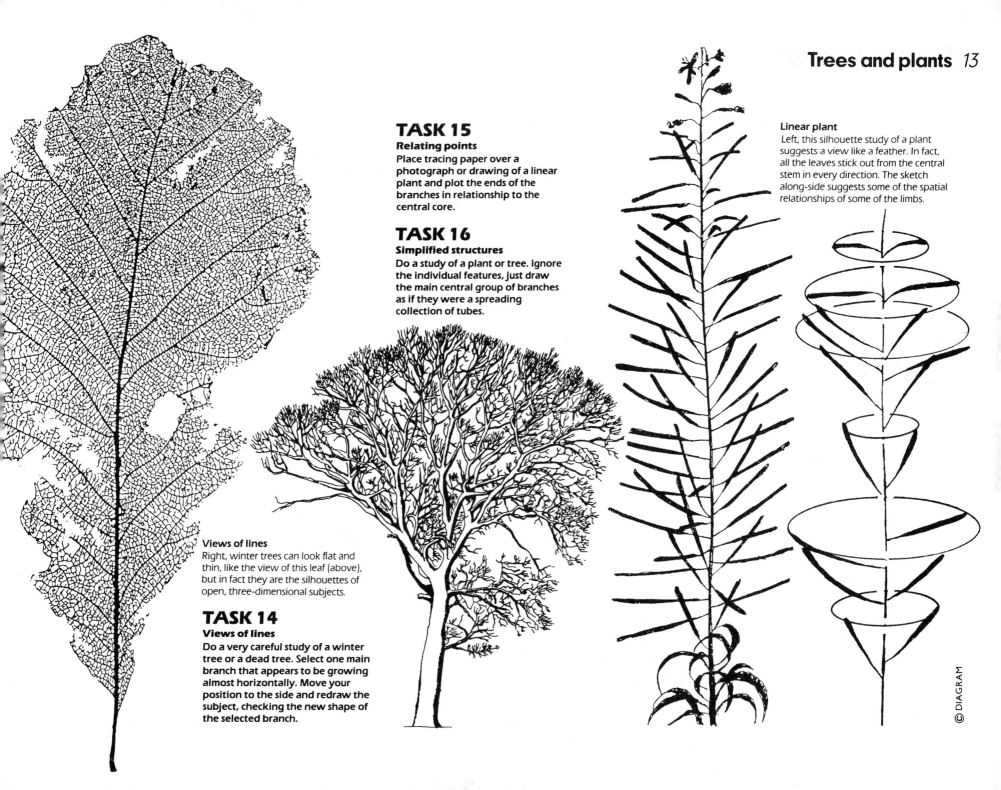

TASK 15

Relating points

Place tracing paper over a photograph or drawing of a linear plant and plot the ends of the branches in relationship to the central core.

TASK 16

Simplified structures

Do a study of a plant or tree. Ignore the individual features, just draw the main central group of branches as if they were a spreading collection of tubes.

Linear plant

Left, this silhouette study of a plant suggests a view like a feather. In fact, all the leaves stick out from the central stem in every direction. The sketch along-side suggests some of the spatial relationships of some of the limbs.

Views of lines

Right, winter trees can look flat and thin, like the view of this leaf (above), but in fact they are the silhouettes of open, three-dimensional subjects.

TASK 14

Views of lines

Do a very careful study of a winter tree or a dead tree. Select one main branch that appears to be growing almost horizontally. Move your position to the side and redraw the subject, checking the new shape of the selected branch.

© DIAGRAM

The ability to capture depth and space in a drawing, which is so vital to a good study, is often helped by the presence of light and shaded areas. Because we think of the source of light as usually falling from above, areas with dark tones indicate that they are beneath, behind or turned from the light source. This feature can be a great help to your drawing.

Branches
Left, the use of shading can help unravel the direction of branches. Dark areas can be used to indicate:
A. Areas turned away from the light source;
B. Areas beneath and shaded by foliage:
C. Areas carrying the shadows cast by other branches.

TASK 17
Branches
On a summer day with strong sunlight, do a pencil study of a group of thick-limbed branches. Take care to record the shadows of the foliage and twigs on the tubular structure of the branches.

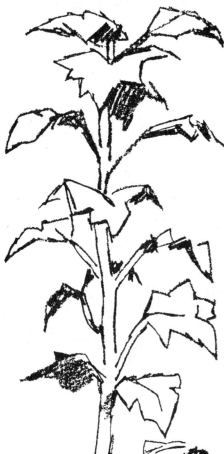

Leaves
Left, in this pencil drawing the underside shading of the leaves helps describe the direction of each leaf on the main stem. Right, the pen drawing uses shading to indicate the surface character of the leaves and their direction.

TASK 18
Leaves
Draw a small plant with a single light source and record the shaded areas very carefully.

TASK 19
Textured volume
Choose a small bush and draw it as a single mass, describing the areas that overlap one another. Think of the bush as having been carved from a block and covered in the texture of the foliage, and draw the general bumps and hollows on the surface.

Light source
Right, this study uses the light source to describe which areas of the foliage are beneath other areas. The part of tree marked **A** is obviously in the foreground and the area marked **B** in the background.

Foliage
The overcast of a tree — its cover — helps you describe its bulk. With evergreens or trees in summer this overall texture of leaves is seen as a simple mass. The problem of how to set about drawing the tree becomes one of drawing a solid object and not a linear net.
Always think of the basic forms:
a. A ball
b. A canopy group
c. A cone
d. A tube
e. Irregular

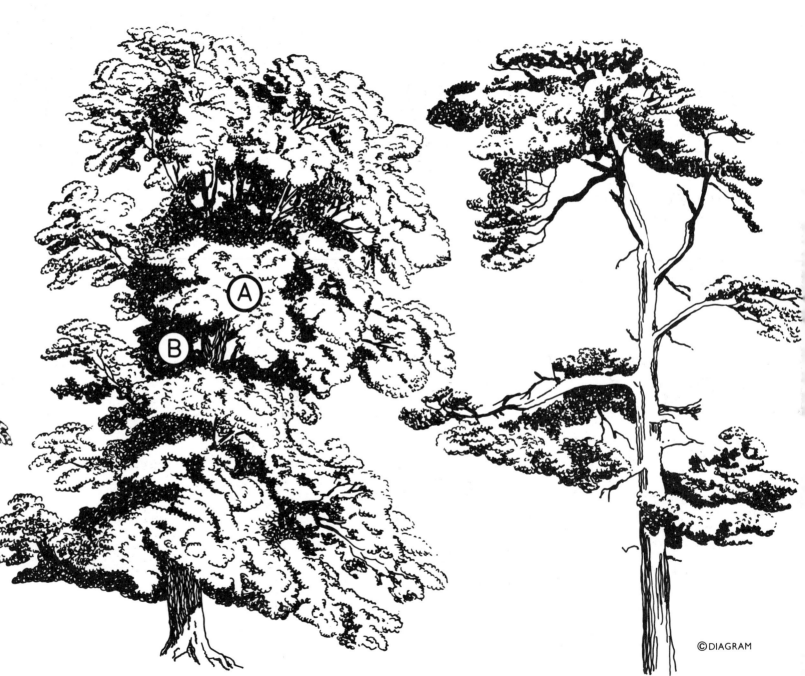

TASK 20
Tree forms
Do a variety of basic shape studies of trees in the park or from photographs or drawings. Use a soft pencil and confine your drawing to describing the light and dark areas only, as in the study (far right).

©DIAGRAM

Using the overall surface qualities of a plant to suggest its shape, as on the previous pages, can be further helped if you consider the type of surface texture a plant has. There are an enormous variety of plant surface textures which, if recorded carefully, give your black and white drawing an appearance of color.

Seeing character
Left and below, the whole is not the sum of the parts. Individual leaves do not necessarily indicate the overall character of a plant. These studies from leaf to apple tree, show the progressive change as you move further away from the subject.

TASK 21
Natural character
Draw a complete tree, then a branch, then a cluster of leaves, then an individual leaf.

Foliage varieties
Below, the classic Chinese 17th-century work 'The Mustard Seed Garden' teaches artists to examine the varieties of texture on plants. This is a small section of the numerous styles of brush marks suggested to record plant varieties.

TASK 22
Drawing varieties
Practice with a brush the different types of marks you can make (see page 39) and convert the picture (opposite) of the imaginary garden to one of brush marks.

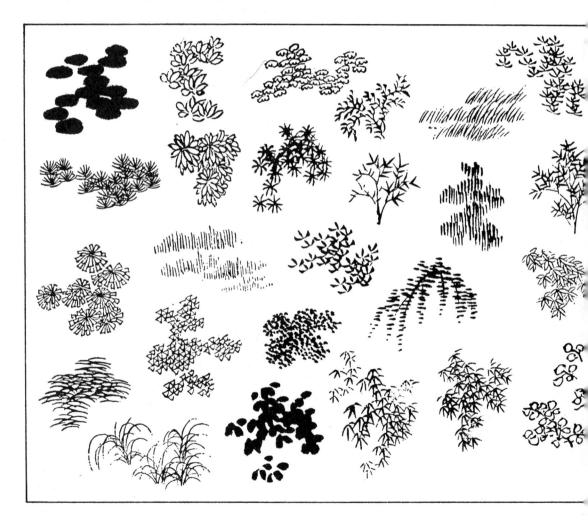

Wild varieties
Right, the 19th-century wood engraver Thomas Bewick was a master at rendering on a very small scale the individual types of plants in his landscape.

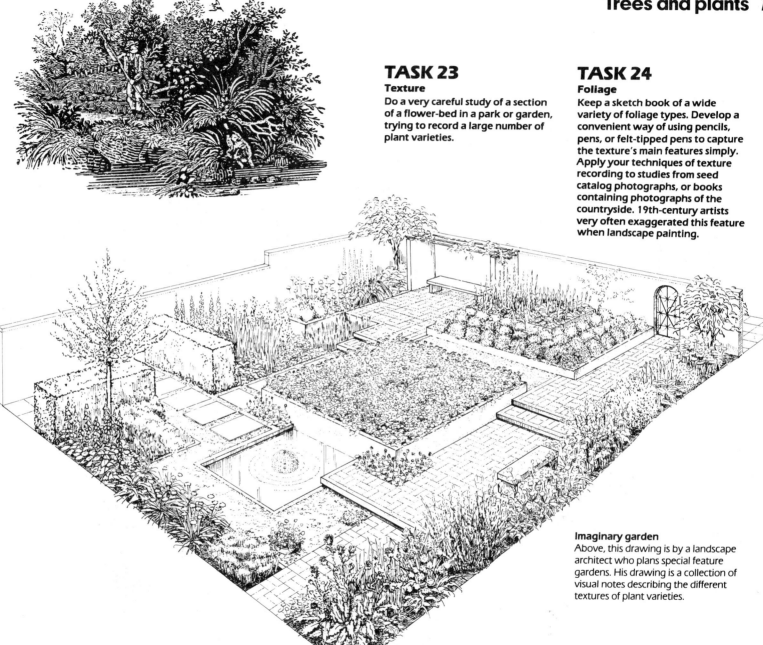

TASK 23
Texture
Do a very careful study of a section of a flower-bed in a park or garden, trying to record a large number of plant varieties.

TASK 24
Foliage
Keep a sketch book of a wide variety of foliage types. Develop a convenient way of using pencils, pens, or felt-tipped pens to capture the texture's main features simply. Apply your techniques of texture recording to studies from seed catalog photographs, or books containing photographs of the countryside. 19th-century artists very often exaggerated this feature when landscape painting.

Imaginary garden
Above, this drawing is by a landscape architect who plans special feature gardens. His drawing is a collection of visual notes describing the different textures of plant varieties.

There is a vast range of plants and trees. Each species has its own characteristic and its unique growing situation. Good drawings should leave you in no doubt as to the species, whether from the leaves, the size of the plant, its shape or the way the parts are arranged. Try to build up a knowledge of botany so that you can more easily recognize a species when you see it.

Japanese garden
Below, a wonderful drawing of the variety of plants in a Japanese garden. Most Japanese readers will be able to recognize the particular plants in the groups.

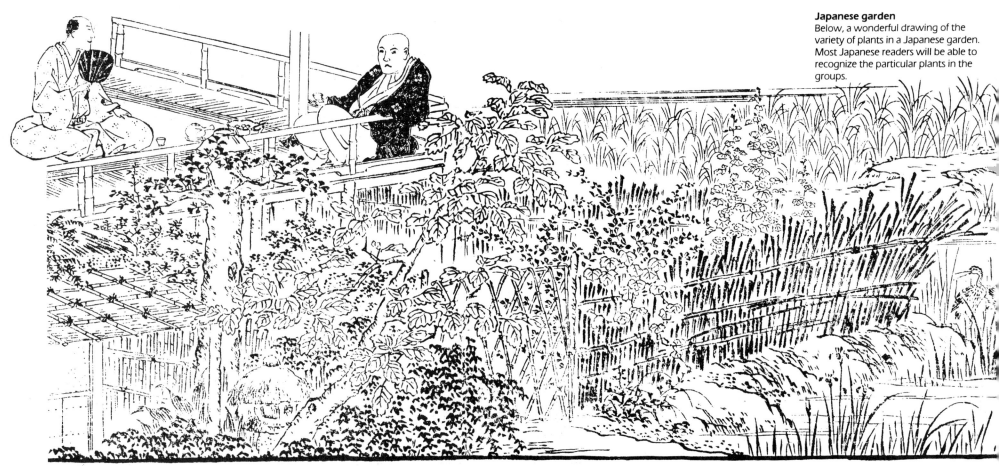

Leaves

Left, understanding the general shape of leaf species helps you draw more accurately the view of the particular leaf you are studying. Nearly all leaves have a symmetrical form, that is, the structure is divided down the center with either side mirroring the other. This must not be overlooked when drawing the leaf's attachment to its branches.

Structures

Plants grow in a regular way – their inner geometry directs them to develop particular forms. Most varieties have one of the following structures:

A. Clusters of stems from a common source.
B. One stem with alternating branches.
C. One stem with pairs of branches.
D. One stem with clusters of branches.
E. Each stem growing from the side of the preceding one.

TASK 25
Structures

Keep one section of your sketch book for plant structures and try to collect notes on the many ways the branches and stems are joined.

TASK 26
General appearance

Practice drawing the total tree in a way that indicates its general character. This is made easier if you study a distant tree that stands apart from all others.

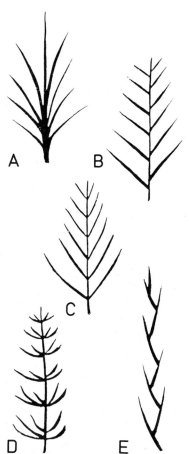

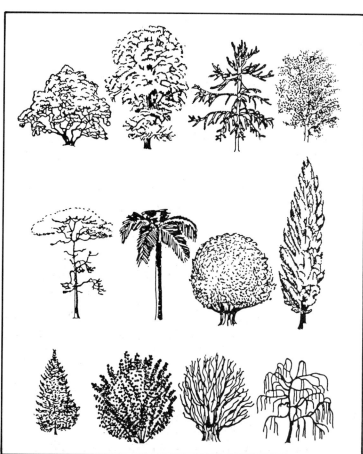

TASK 27
Leaf shapes

Keep a collection of dried leaves. Press examples of different shaped leaves in an old book, and perhaps keep a record by drawing around the edge of the different types you have been able to find.

General appearance

Left, because of their different structures, trees can be recognized by their overall appearance. They are often tall or short, thin or fat, heavy or light, upward pointing or downward pointing, straight or irregular.

TASK 28
Exotic forms

Use travel books or visits to a botanical gardens to sketch plants that do not grow locally. Draw palms, cacti, ferns, creepers. Often indoor garden plants have strange leaf shapes.

© DIAGRAM

Influencing factors
Not only are plants very varied, but each drawing has a number of influences on its appearance. It will be the result of your experience, the marks the tools make, the purpose of the study, and your cultural origins.

TASK 29
Variety
Study botanical books and learn to identify types of plants and trees.

TASK 30
Artistic diversity
Collect examples of artists' drawings of plants and trees that display decorative designs in books, magazines, and posters.

TASK 31
Artistic style
Copy the drawings of famous artists. Try to understand what tools they used and, if possible, identify the species of plant.

TASK 32
Presentation
Check that you signed and dated all the drawings you have done. Then make a notice board of hardboard or cardboard and pin up your most successful study for criticism by your friends and, most importantly, by you.

The previous 32 Tasks
Direct your attention to looking carefully at what you can see in the subject. Here are some examples of artists responses to their observations.
1. 16th-century drawing of a plant. This type of drawing is offered to enable you to identify a species you find.
2. 20th-century drawing of grass produced for the same reason.
3. Japanese brush drawing that captures the beauty of the plant.
4. Recreational study by child, aged 9 years, learning to record what she saw.

1

2

3

4

UNDERSTANDING WHAT YOU SEE

All plants and trees are three-dimensional – they exist in space. It is important to think of the space they fill and the space in which they stand.

Your drawing is an invitation to step into the same space as the subject and to experience its solid three-dimensional existence.

There are twenty-eight Tasks to help you achieve a special quality in your drawings.

- We start by considering what space looks like. Pages 22 to 25 describe the way plants and trees change their appearance, depending upon their location within your picture.
- Pages 26 to 29 examine branches and stems. A study of them will reveal their directional growth, and we look at how you must always locate them in the picture space.

- Pages 30 and 31 highlight the artist's traditional use of lines and tones to describe how leaves and branches overlap one another.
- Next, pages 32 and 33 set you four Tasks to enable you to understand that the thin flat qualities of a leaf may appear irregular, but are, in fact, distortions of simpler shapes.
- Finally, page 34 suggests how to apply your discoveries to a photograph.

The world is an open spacious environment. When out on location, plants are identifiable in the foreground, trees in the middle distance and both combine to form shapes in the far distance.

Spatial properties
Your drawing of space is helped by five techniques:
1. Haze – loss of detail in distant objects.
2. Surface detail – foliage of plants and trees.
3. Scale – size and detail of plants diminish the further they are from you.
4. Base position – the position of objects relative to each other.
5. Overlap – the amount by which each plant obscures others.

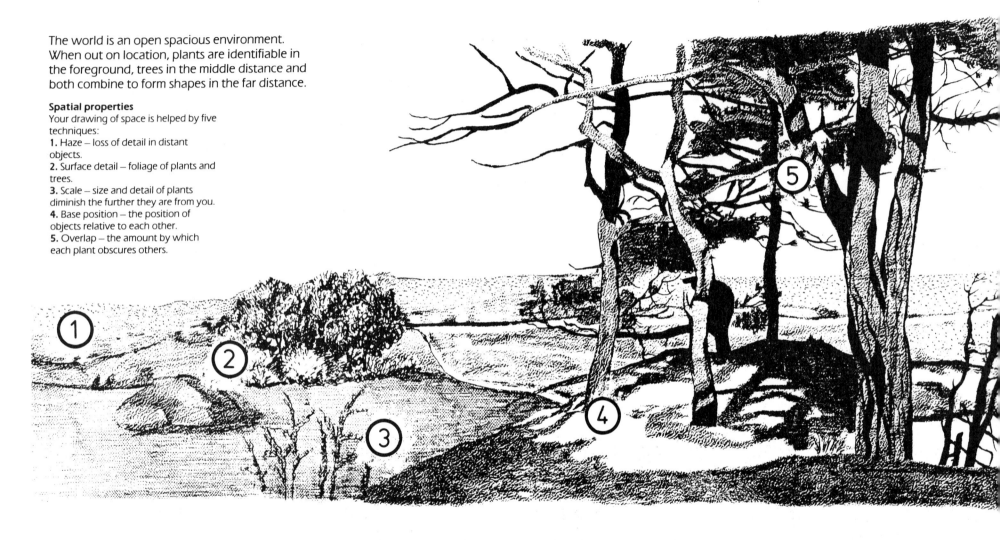

The five features of space
1. Haze
Distant trees are seen as flat shapes. The area between you and far distances make them appear to have less color than foreground objects, and also to be simpler in form. In effect, they merge into one another.

2. Surface detail
As foliage recedes into the distance, so our ability to observe its tiny individual features decreases. We see more textures in foreground objects than in distant ones.

3. Scale
Although plants grow to many different heights, our knowledge of the appearance of their adult size helps us to locate them within the landscape.

4. Base position
By our observation of the heights, we judge the location of the base of each plant and tree. This fixes the object within the receding surface of the landscape.

5. Overlap
We understand positioning in space by the amount one object overlaps and obscures another. This is clear of each object as well as its parts.

Spatial transfer
Right, you view the subject as if through a glass sheet. This imaginary surface, the picture plane, is set a right-angles between you and the subject. If you were to walk around a tree or plant, you would observe its three-dimensional properties, but when doing a drawing you have only two dimensions on to which to record these features.

Normally the following is true of your drawings:
Vertical (**A**) and horizontal (**B**) directions will be constant, and reduce proportionately into the distance. Recessional directions (**C** and **D**) will appear distorted so must be drawn to APPEAR to protrude and recede.

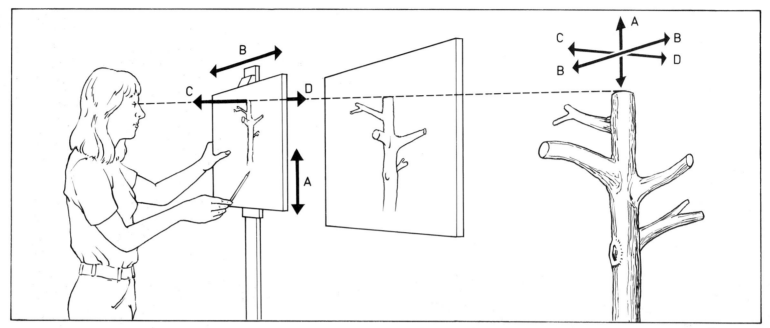

©DIAGRAM

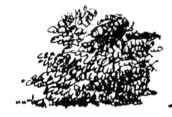

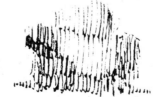

Diminishing detail
Drawings of the same bush seen from varying distances. Each receding view of the object reduced its size. Although it appeared smaller the further it was away, the bush is reproduced the same size on each occasion so as to emphasize the change in detail.

TASK 33
Scale
Draw a landscape that contains a row of trees of similar height. Sit near one end so that they appear to diminish the further they are away from you.

TASK 34
Bases
Draw a group of trees or plant pots on a patio, and plot carefully their base points in relationship to one another. A street of trees is a good exercise as the sidewalk provides a clear guide to their base positions.

TASK 35
Overlap
Draw a group of trees in full foliage that overlap one another. Shade the near ones darker than those in the distance. Treat each tree as a cut out, flat shape.

TASK 36
Detail
Sit close to a small bush and draw as much of the detail as you can. If possible, draw every leaf! Move away and do another drawing, recording only the form and shadows of its foliage. Move even further away and draw its silhouette.

Although it may seem obvious that distant objects appear smaller than similar sized ones in the foreground, this is often unnoticed by beginners. When in doubt about the size of two objects, a distant one and a near one, check their heights one against the other.

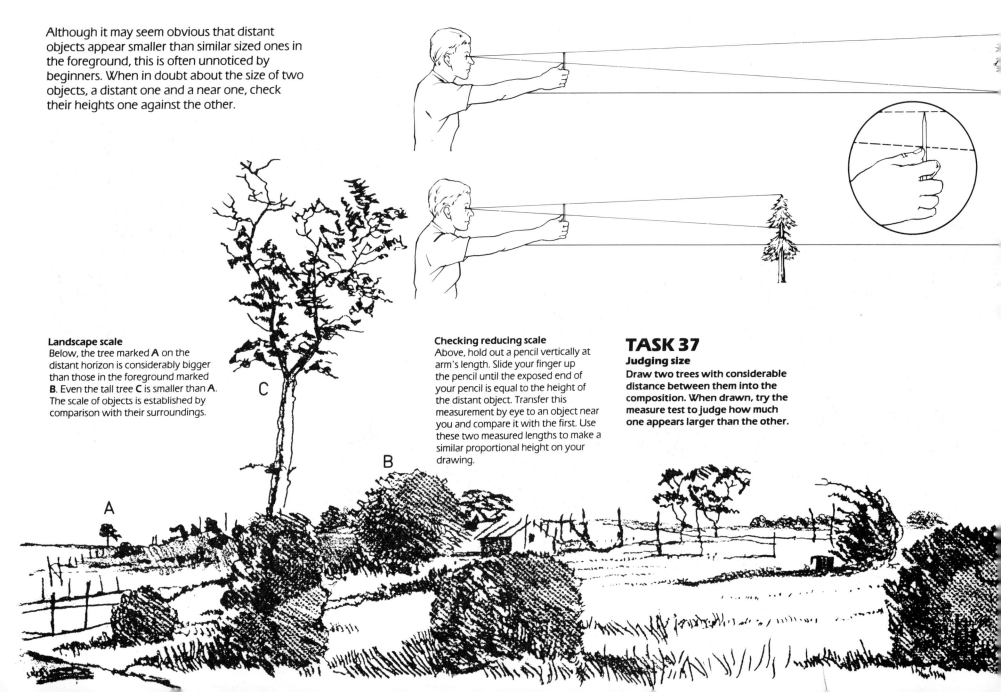

Landscape scale
Below, the tree marked **A** on the distant horizon is considerably bigger than those in the foreground marked **B**. Even the tall tree **C** is smaller than **A**. The scale of objects is established by comparison with their surroundings.

Checking reducing scale
Above, hold out a pencil vertically at arm's length. Slide your finger up the pencil until the exposed end of your pencil is equal to the height of the distant object. Transfer this measurement by eye to an object near you and compare it with the first. Use these two measured lengths to make a similar proportional height on your drawing.

TASK 37
Judging size
Draw two trees with considerable distance between them into the composition. When drawn, try the measure test to judge how much one appears larger than the other.

TASK 38
Context
Place tracing paper over a landscape picture and, using a felt-tipped pen, draw a distant tree. Move the drawing to a foreground position and compare its new scale with surrounding objects.

TASK 39
Diminishing scale
A field of grass or wheat contains plants of similar height. Do a landscape drawing in which the foreground plants are drawn with bold, strong lines, and the distant tones with tiny fine lines.

TASK 40
Regular reduction
Draw an avenue of trees of similar height. Take special care to check their base positions and their heights.

Recessional objects
Right, objects of a similar height diminish on a regular scale. This is very apparent with an avenue of tall trees.

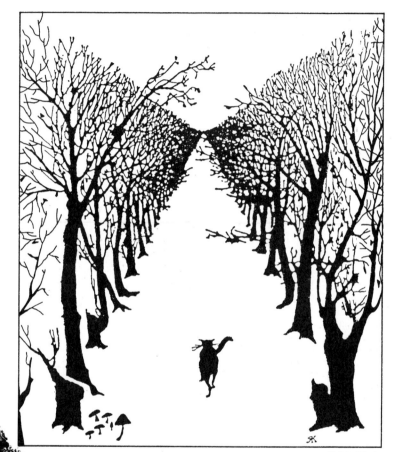

©DIAGRAM

The life of a plant shows in the strength and shape of its branches and stems. Its tensions are a key factor to capture in your drawing. Each branch is flexible yet firm, and the weight of the leaves acts to produce a curve on the lines of growth which you must portray in the lines of your drawing.

Life force
Right, this pencil drawing of a spring flower has a good sense of tension. The thrusting twist of the leaves and stem gives the drawing its vitality.

TASK 41
Life forces
Draw a young new branch or plant, trying to capture its springy, fresh, life force.

TASK 42
Understanding joints
Draw a branch and its stems taking care to study very carefully the joints between the branches and stems. Look for evidence on the branch of removed stems.

TASK 43
Surface clues
Draw a limb of an old tree, taking care to record the textures and changes of direction of the branches growing from the limb. Note that points on the edge appear closer together.

Branch types
Left, two silhouette studies of branches of trees. The top branch has paired stems, the bottom has individual stems.

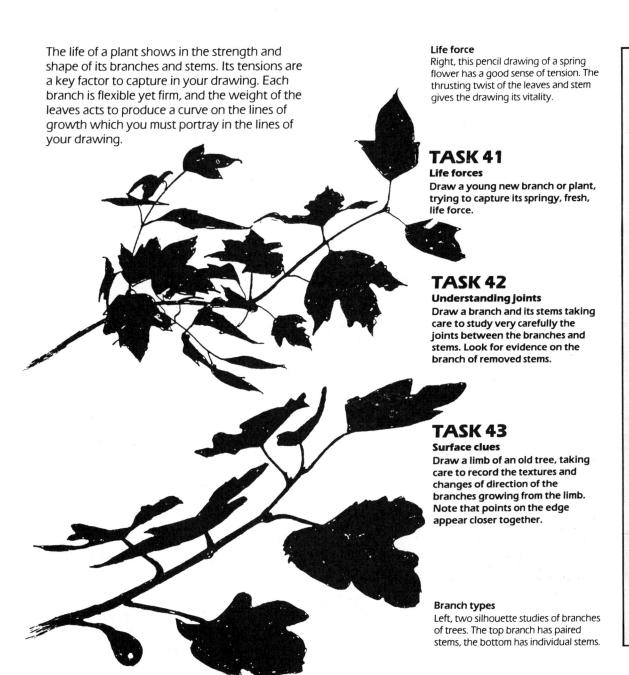

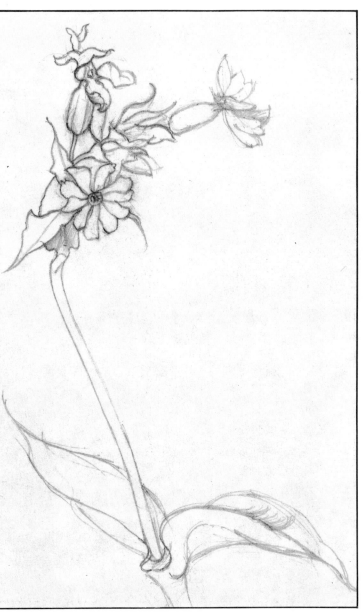

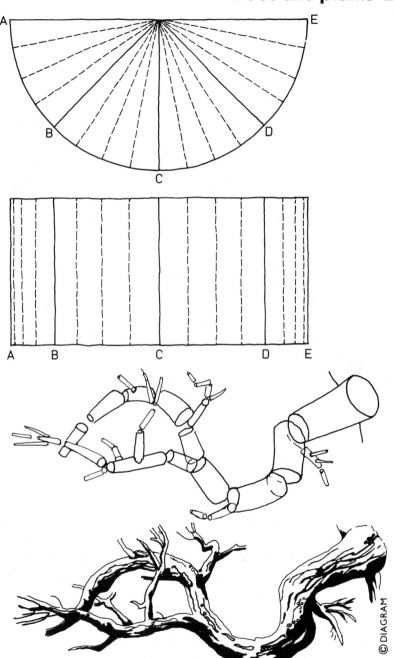

Tubular effects

Right, all limbs of plants are circular in section. Because the surface is curved round and away from you at the edges, points on the surface appear to become closer to one another as they approach the edges.

For example, **A**, **B**, **C**, **D** and **E** are all equal distance on the surface but appear to get closer on the outer edges.

Trunks

Left, studying the irregularities of an old tree helps you to record more accurately the volume and direction of the limbs. Each strut produces shadows on the surface of the bark and the texture of the bark will reveal tiny clues as to its direction.

Seeing tubes

Right, branches are tubes. A cluster of spreading branches can best be described by thinking of them as tubes pointing in a variety of directions. You can see this effect more clearly if you imagine the branches cut up into small logs. Each log should be separated at the point where it grows from another or from where it changes direction.

TASK 44
Volume

Draw a large branch as if it were sections cut into small logs, each rejoined at the branching point. Note very carefully the changing directions.

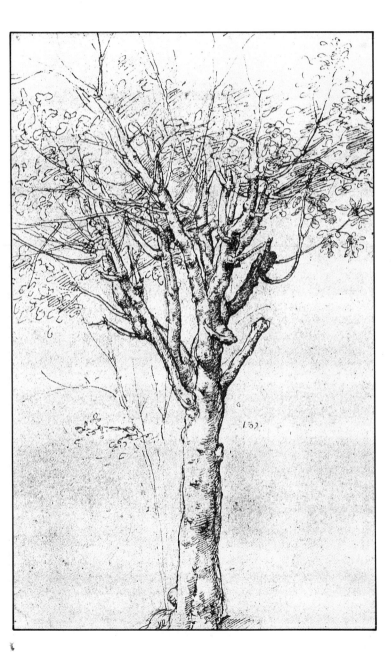

©DIAGRAM

Studying the points at which plants grow from the earth can be very helpful in establishing their positions in space. The plotting of ground points and the construction of contours are often overlooked by beginners. While they may produce wonderful studies (such as the drawing below by Helen, aged 11), they lack any understanding of how the edges of the vase should be constructed.

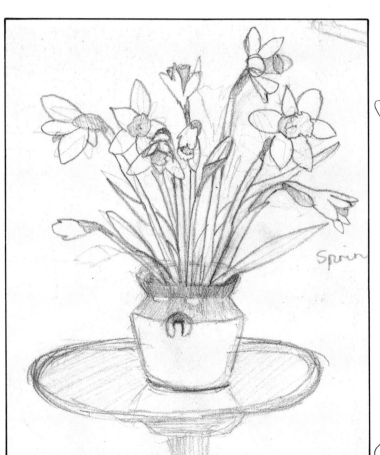

A

B

C

Drawing circles

Right, always remember some simple rules:

1. All circles fit into squares, touching the four sides at points on the center of each side.

2. All circles on vases and pots have their center points located on the central axis of the object, usually one above the other.

3. Usually circles describe horizontal discs, so these change depending on your viewpoint. Those level with your eye appear condensed and you see less of their surface (**a**). Those lower down (you are looking on to them) reveal a more circular form (**b**).

TASK 45

Understanding circles

Copy on tracing paper overlay the circular elements of vases and pots. Use trade catalogs and any photographs of objects where there is a variety of circular elements. Candlesticks, table legs, vases, all have horizontal circular elements.

TASK 46

Drawing circles

Left, draw a plant pot. Place it on a table and sit low down so that the pot's edge appears as a straight line (**A**). Do another drawing, placing the same pot on a chair located approximately 3ft (91.4cm) away from you. The rim of the pot will now appear as an oval (**B**). Finally, place the pot on the floor and do a drawing looking down on the subject. The rim should now look circular (**C**).

1

2

3
a

b

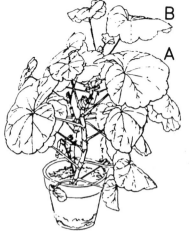

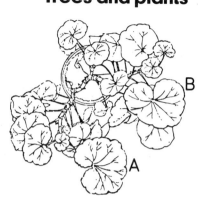

TASK 47

Comparing relationships

Below, push three sticks into the ground in the form of a triangle. Join their bases together with string to form a spatial net revealing this arrangement. Do a series of drawings from different distances from the group and notice how the triangle appears thin and shallow as you recede from the subject.

TASK 48

Winter roots

During winter the base points of plants can be more easily observed. The drawing (below) of a field of bare fruit bushes in snow clearly shows the position of the bases. Do a drawing in the park or countryside of a group of bare winter trees.

Understanding space

Right, the two views of the plant on pages 6 and 7 were to be compared to help you locate the positions in space of the leaves. Did you correctly identify the same leaves in both drawings?

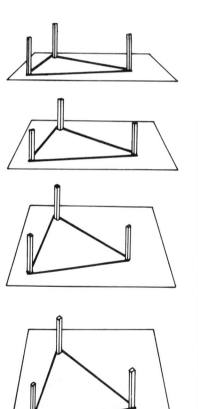

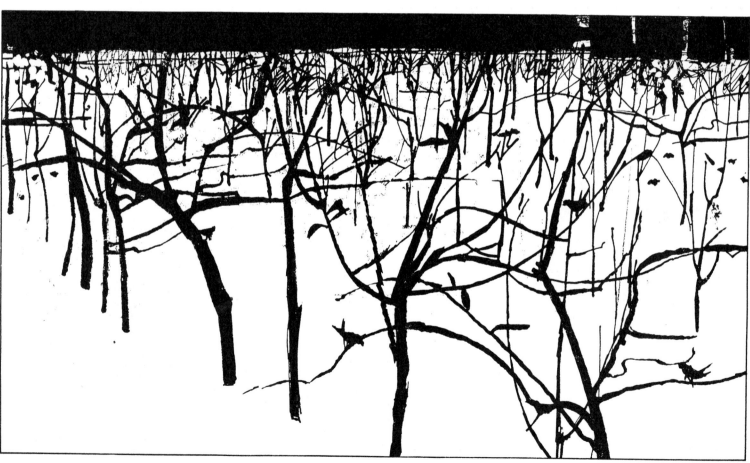

The two main techniques used by an artist to create an illusion of space are overlapping of lines and the softening and lightening of those lines meant to be more distant. Both are drawing conventions and if used carefully can give your drawing a greater sense of depth.

Drawing space
Three methods of obtaining a sense of space – overlap, line emphasis and tones.

Overlap (1)
Above right, tree **B** is clearly four trees behind tree **A** and although tree **B** is drawn the same height as tree **A**, it is clearly the tallest if set so far into the picture.

Line emphasis (2)
Far right, all the leaves are drawn the same size, but because of overlap and the increased thickness of lines some appear closer to the surface of the drawing than others.

Tone (3)
Below right, the branches appear behind or in front of one another because of overlapping lines, changing line thickness, and the addition of tone implying cast shadows.

Overlap
Left, a line drawing in which every element is recorded as if it were a flat surface parallel to the picture. This is a network of lines describing a three-dimensional object. The only concession to space is that some leaves overlap (so must be in front of others).

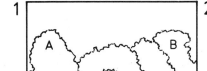

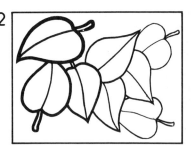

TASK 49
Explaining overlap
Place tracing paper over the drawing (left) and with a pen draw in thick lines all the leaves you think are nearest to you. Next, reduce the thickness of lines as you describe the leaves further from you. If you find this technique successful do a drawing from a study of a plant in this way.

TASK 50
Haze
Place tracing paper over the same drawing (left) and shade the leaves without drawing their outlines. Use light tones to describe leaves furthest from you and darker tones on the nearest leaves. If you find this technique successful, do a plant study from life.

Haze
Above, distant objects appear less detailed than those in the foreground. This is more true over greater distances, but the technique can be used when drawing an individual plant. This drawing uses haze to place the leaves in space.

Overlapping textures
Drawing the thin elements of a plant often presents only a silhouette of their volume and direction. Nevertheless, you must always be careful to draw in the overlapping features as these place each part in its correct spatial position. Below, four drawings of the same plant:

A. The edges give little clues telling you which leaves and branches are in front of others.
B. The same outline with details of overlap to explain positions.
C. Exactly the same outline, but with a completely different explanation within the shapes as to the positions of the leaves and branches.
D. A completed drawing with inner detail added to aid understanding.

TASK 51
Line overlap
Do an outline drawing of the illustration on page 7. Use the edges to carefully describe where the objects overlap.

TASK 52
Reading edges
Trace the outline of the plant (right) onto a sheet of tracing paper, then add inner details to explain which leaf you think overlaps others. Check your attempts with the plant on the Contents page.

A

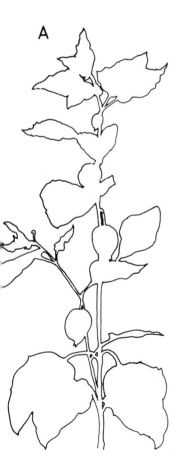

B

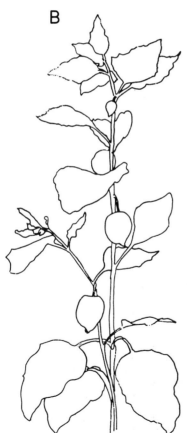

C

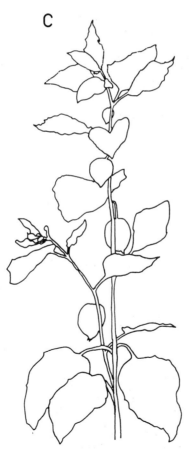

D

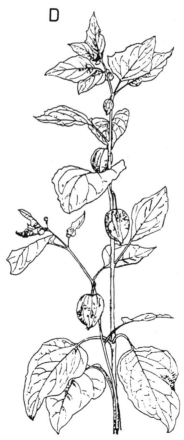

©DIAGRAM

All natural forms have a pattern of construction which is the result of their growth. However irregular a leaf or flower may appear, it is nevertheless conforming to nature's secret geometry. When drawing an individual flower or leaf it is useful to consider its basic shape.

Most flowers are circular with the petals radiating like the spokes of a wheel from the stem. Most leaves are symmetrical, one side being a mirror-image of the other, along a spine. The structure of a leaf radiates from the spine like a fan.

When drawing individual leaves or flowers three factors influence their appearance. Firstly, their natural species' characteristics, with the added tiny, unique variations of each object. Secondly, the way the object twists and turns as it grows. Finally, your view of the plant from where you are looking at it.

TASK 53

Twisting and curling

Draw a leaf shape within a rectangle, so that the edges of the box touch the tip, sides and stem of the leaf. Cut out the rectangle and place on a hard surface. Rub the paper with the back of a comb or ruler and the paper will curl. Draw the twisted shape and the new leaf shape.

Rubbing the paper in different directions or on the back produces different twists and curls.

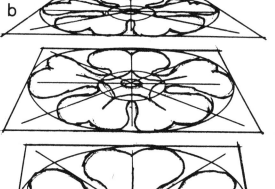

Leaf form

Above, simple leaf shapes can appear very complex when they twist sideways and bend forward. It is always advisable to think of them as flat shapes, within a rectangle, then consider the distortions of the rectangle as indicating the unusual shapes of the leaf. Always keep in mind the idea of a center line running from the stem to the tip, and begin by sketching in the distortion of that line before plotting the outer edge.

Petaled flowers

Right, the wheel-like radials of petals can best be understood in plan view (**a**), but so often the flower appears in a different picture plane to the surface of our drawing (**b**).

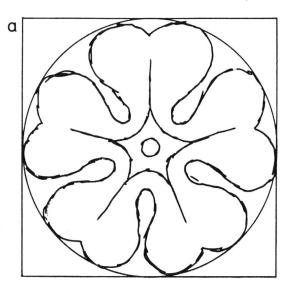

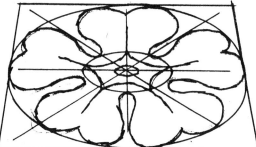

TASK 54

Flower shapes

Cut out a simple circular pattern of petals. Then draw the cutout from a variety of different views. First, a position directly over the shapes (a plan view). Next, one seen from above at a slight angle, and finally, one seen low down, almost from the side. Each time check that you have positioned the petals in the correct relationship to one another.

Grid distortion
Thinking of the leaf as a flat, regular, outlined shape that is twisted and curled by a regular grid helps to plot the edges more accurately.

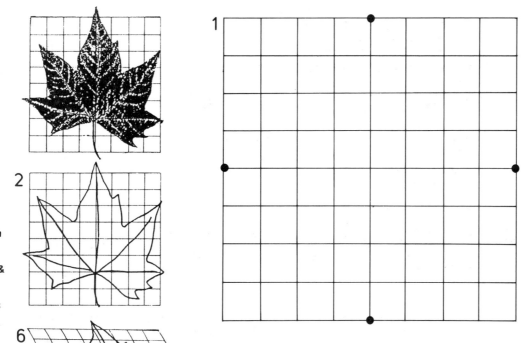

TASK 55
Grid distortion
Using tracing paper and a soft pencil, copy the squared grid on this page (1). Place your grid over a leaf of similar size and copy the outline (2). Trace off another distorted grid from this page (3, 4 & 5). Where the outline of your leaf cuts your grid, replot the inter-sections on to your new distortions (6). The resulting new leaf shape will create a drawing of a leaf bending in space.

TASK 56
Changing the shape
Working on a tracing paper overlay replot the leaf. Each time begin with the stem on an edge dot.

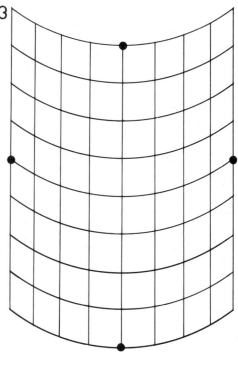

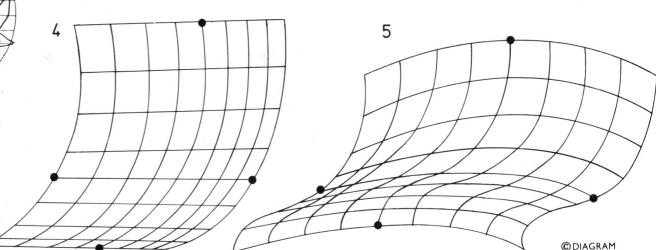

©DIAGRAM

Copying photographs

This chapter was concerned with explaining your impressions and how you recorded them accurately using conventional drawing methods. All drawing is explaining to yourself the space and form of reality, and for this reason working from nature is the best source of information. Nevertheless, photography can be of use in testing what you think you understand of the objects within your view.

When you first examine this photograph it appears normal but a little strange. When you try to copy what you see in the photograph it becomes less understandable. Before you begin the next four Tasks, turn the page around, viewing the picture upside-down and see what further sense it then makes.

TASK 57
Base points

Do a small sketch plan of the picture, locating the base points of the trees along the river bank.

TASK 58
Scale

Imagine you could walk away from the picture to obtain a full view of all the trees. Do a sketch of all their heights.

TASK 59
Texture

Do a drawing of the picture and carefully describe the various textures of trees, water and plants.

TASK 60
Shapes

The picture contains two types of trees. Draw an example of each, side by side.

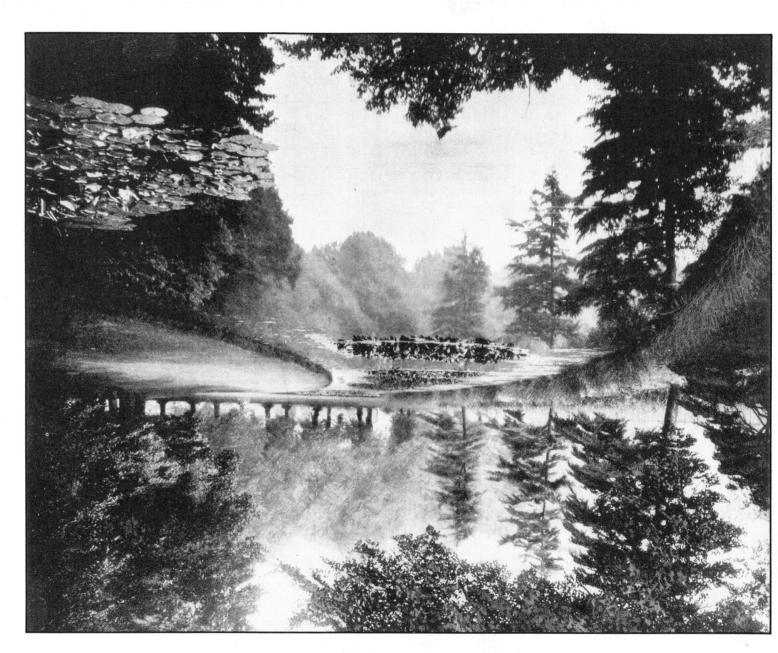

MASTERING TOOLS

This chapter is about the marks you make when drawing, the surfaces you work on and the tools you use. Every tool is useful but you will find some more convenient than others and, therefore, more comfortable to use. When working on location, take the tools which you most enjoy using. There will be opportunities at home to experiment with unusual tools or papers.

Twenty-five Tasks invite you to appreciate the qualities of the lines and tones of a drawing – the graphic qualities of your art.

- We start, on pages 36 and 37, with reviewing all the drawing tools normally used by beginners.
- The next two pages, 38 and 39, show the quality of lines achievable with pen and brushes – tools with which you may not feel so comfortable.
- Pages 40 and 41 contain examples of working with tones. They show you how to build up the values of light and color with brush and pencil.

- Pages 42 to 45 encourage you to work out of doors, taking the knowledge acquired while studying indoor plants to the wild flowers and landscape of the countryside.
- Finally, page 46 reviews your working habits and needs. Do you have the correct equipment? Are your materials correctly sorted? Are your drawings preserved with care?

Whatever you choose as a drawing tool is of little relevance to the quality of your work if you feel comfortable using it. Normally beginners use pencils as these offer a wide range of marks and can be corrected with an eraser. In addition to the most familiar tools, use also those with which you have no experience when you have the time to explore their effects.

Types of tool
a) Dry-medium tools: pencils, charcoal, chalks and crayons.
b) Wet-medium tools: ball-point pens, felt-tipped pens, technical drawing pens and brushes.

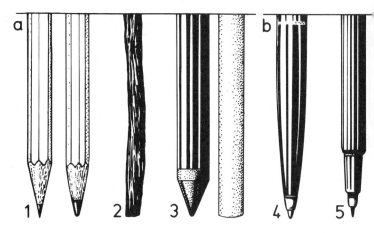

Types of tool
There are two main types of tool, dry-medium tools and wet-medium tools. Usually, the dry-medium tools work best on rough surface papers and the wet-medium tools on smooth surfaces. Brushes work on both smooth and rough surfaces, but are best on thick, strong paper as the dampness of inks can cause thin paper to buckle.

Dry-medium tools
Range:
1. Pencils; these are sold in a variety of strengths depending on the grade of the lead. H pencils are hard (thin faint lines), B pencils are soft (broad black lines).
2. Charcoal; this is not very suitable for plant drawing.
3. Chalks and crayons; these are good for landscape studies.

Pencils
The most popular, and easiest to use, tools are pencils. They produce a wide range of tones, and for most drawing surfaces their marks can be removed with a good clean eraser. They can be made to produce a wide variety of line thickness, or areas of tone that are built up into grays without showing the individual marks. The drawing (left) by Jane, aged 21, of spring buds uses the soft quality of the pencil to build shading and texture in the subject.

TASK 61
Caring for tools
Sort out your tool box or drawer. Make sure that all your pencils have sharp points and discard any that produce broken leads when sharpened. Make sure all your brushes have been washed clean of ink.

TASK 62
Judging tones
Draw a large leaf and, using a pencil, shade it in to try to capture its exact tonal value. Repeat the study using a pen and cross-hatching, and try to match the apparent effect of the pen lines with the built-up pencil tones.

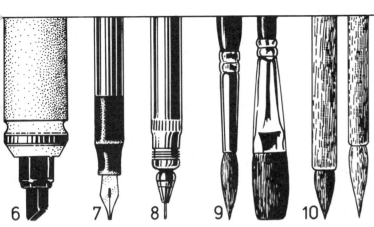

6 7 8 9 10

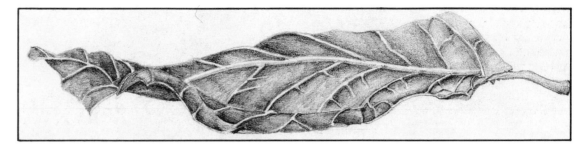

Commercial marking tools
Above, ball-point pens and felt-tipped pens with broad or narrow points are good for quick sketches. This drawing was made with two felt-tipped pens, one with a fine point for drawing the detail, and one with a broad point for filling in the darker areas. None of these tools allow you to alter the drawing once you have made the marks.

Wet-medium tools
Commercial writing tools are useful for drawing as they are convenient and can be replaced easily.
Range:
4. Ball-point pens; although usually not considered suitable, they are good for quick sketching.
5. Fine felt-tipped pens; these are good for studies of detail, but it is only possible to build line drawings with them.
6. Broad felt-tipped pens; good for solid areas.
7. Traditional writing pens; these give a good variety of line thickness, but are difficult to use on rough surfaces.
8. Technical pens; good for indoor studies of detail. They produce a consistent line without varying thickness or weights. Not suitable on rough surface paper.
9. Brushes of varying thickness; they produce an excellent quality of line, but are often inconvenient when working on location.
10. Oriental brushes; wonderful to use, but often difficult to acquire.

Drawing qualities
Above and right, these two studies of leaves show very clearly the different effects produced by tools. The drawing made with a pen (right) has the tonal areas described by layers of crossing thin lines. The drawing (above) is made with a pencil and here the tones are achieved by gently building up layers of marks with a soft pencil so that individually applied lines cannot be seen.

TASK 63
Line variety
Do a series of drawings of the same subject, such as a small plant in a pot. Make each drawing approximately 6 in (15cm) deep. Make each drawing of exactly the same view, but with each drawing try a different tool. Pens can offer greater detail than others, such as chalks.

TASK 64
Brush work
Collect together all your previously drawn Tasks and select one you think will convert to a brush study. Practice working quickly and freely, and do not worry too much about following the subject in detail. Use the pen to capture the gesture of the plant.

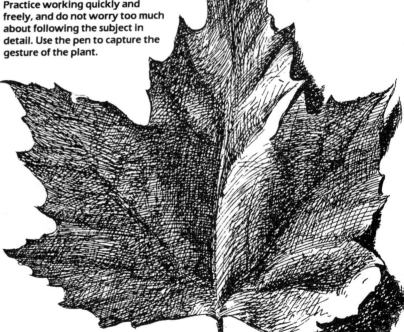

©DIAGRAM

Pens and brushes are good for capturing the spring and bounce of plants – their life force. The varying thickness of pen and brush lines means that you can use them to express the tensions and slackness of a fine branch. Both tools require you to work with speed to achieve a sense of energy, so it is often a good idea to do a pencil study first, then when you have committed the subject to memory, quickly produce a brush study.

Building tones
Left, pens are not suitable for drawing tonal values and Task 63 on the previous page will have revealed this. This drawing has successfully captured the gloss of the leaf but has a very laborious way of indicating shadows.

TASK 65

Exploration
Don't be afraid to have fun with your tools. It frees you from your inhibitions. The drawing (left), made with a pen, was produced by a method that usually does not create attractive results but can help you see subjects more clearly.
1. Select a simple plant.
2. Sit facing the plant with your drawing pad and pen on your knee.
3. Focus your attention on one point on the plant and trace carefully with your eye the contours of the plant, starting along the edge of a leaf.
4. Follow very slowly and carefully with the pen on paper, but do not look down at your drawing.
5. Only look at the paper when you replace the pen after filling it with ink.

Capturing life
Above, this pen drawing of tropical grass is not a study of individual leaves. The broad thick-ended marks with fine tails are made to resemble leaves by pressing the pen hard when beginning the line, and releasing it quickly when completing the line. The marks imitate the leaves.

TASK 66

Capturing life
Select a cluster of long grass or thin-leaved plants and do a similar pen drawing. Work on smooth paper with a thin solution of ink that flows smoothly.

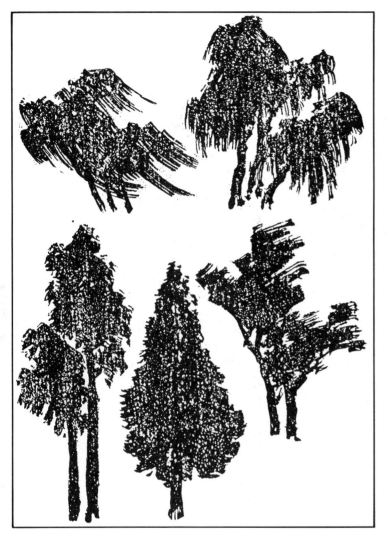

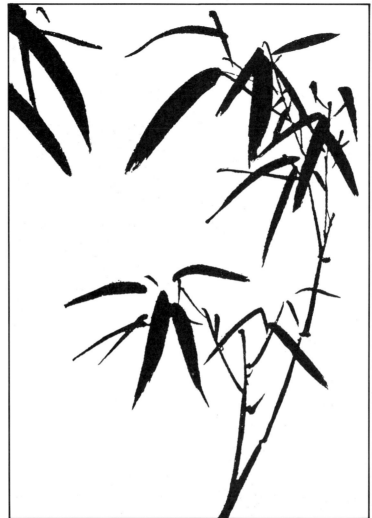

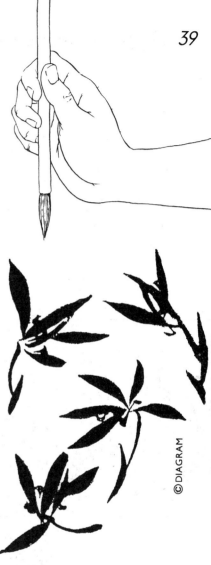

Movement
Above, these wonderful drawings of trees in a storm were drawn by the 19th-century Japanese artist Hokusai. He used a large brush, applying the ink boldly in the direction of the wind.

TASK 67
Brush strokes
Practice with a brush the technique of producing lines that have fine ends but fat center areas. Once you feel you understand how to make satisfactory brush marks, do a series of drawings of the same plant. It is better to draw grass-leaved plants than those with irregular or rounded leaves.

Vitality
Above, bamboo leaves in a 17th-century Chinese drawing instruction book. Each leaf is a single brush stroke. Each section of the stem is a single brush line. This sort of drawing does not allow for revision or correction.

TASK 68
Oriental art
Obtain a book of Chinese or Japanese art and copy the drawings. You must always try to make only the same number of marks on the paper as the original artist. If you use any tool other than a brush, you will produce a drawing with a quite different effect.

Technique
Above, one method of obtaining variety of line thickness is to hold the brush in a vertical position with only your wrist touching the paper. You obtain variations by lowering or raising your complete hand.

© DIAGRAM

Because leaves and branches usually do not form a solid surface to record, the use of tones can help sort out the visual confusion of the individual elements. Pencils, brushes and chalks can be used to create the values. Pens are not suitable as you can see from the pen drawing of the leaf on page 38, where the artist had to build the tones laboriously with cross-hatching.

Creating tones
Below, this is a pencil outline with brush and wash fill-in. Opposite is a soft pencil study.

TASK 69
Variety of tones
Draw a vase containing a group of different leaves and flowers. Try to capture the range of tones on the petals, leaves and stems.

Pencil study
Below, the soft pencil study of a plant in which the tones are carefully recorded.

TASK 70
Light and shade
Make a pencil study of a plant with a strong source of light. Draw the leaves in the normal way, but fill all the shadows in strongly.

TASK 71
Building tones
Place tracing paper over the line drawing below and with a pencil build up a tonal drawing of the leaves.

TASK 72
Surface qualities
Using pencils, draw a plant with large leaves. Try to capture the way the light falls on the leaves, revealing the bumps and hollows on its surfaces.

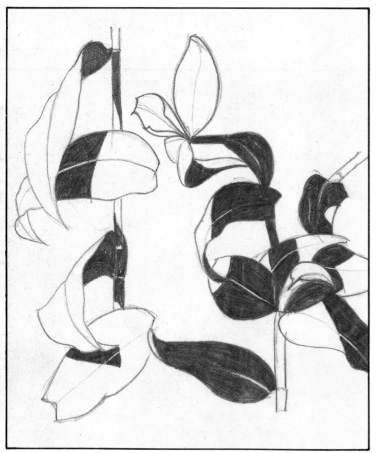

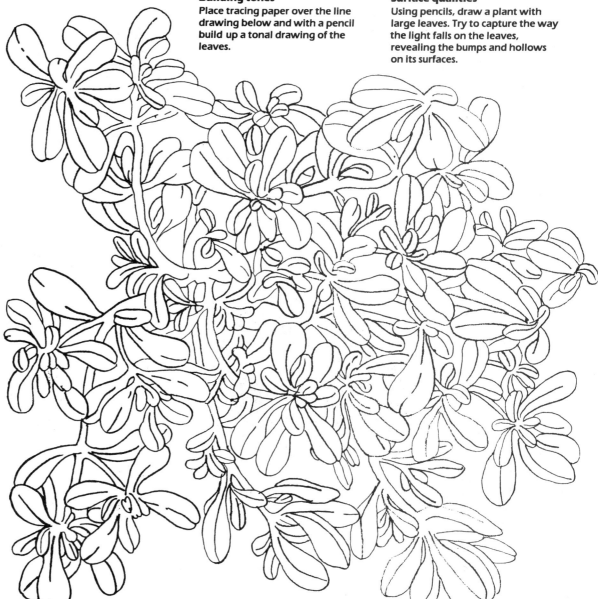

The best outdoor drawing tools are the ones you feel confident with. Pencils, ball-point pens, felt-tipped pens, are all good, convenient drawing tools. Using pens or brushes on location requires you to take ink and water, which may be difficult to hold while you are working.

Exploring texture
Below, pen drawing of foreground plants and middle-distance trees where the different textures can be explored by using scratchy pen lines.

Capturing life forces
Left, pencil study of a sunflower where the forceful lines describe the growth and not the texture, space or tones of the plant.

TASK 73
Life force
Using any drawing implement, draw a growing plant, paying the maximum attention on the force of its stems and leaves.

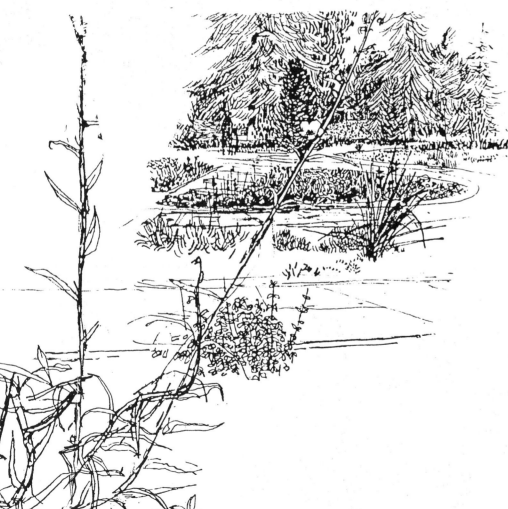

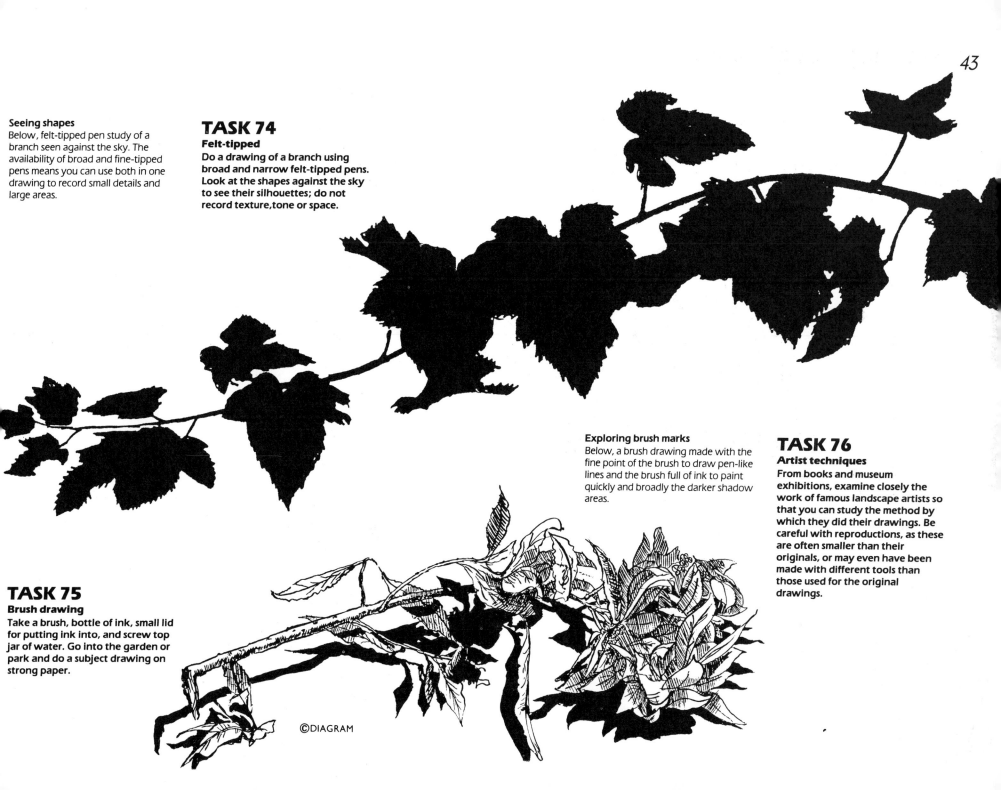

Seeing shapes
Below, felt-tipped pen study of a branch seen against the sky. The availability of broad and fine-tipped pens means you can use both in one drawing to record small details and large areas.

TASK 74

Felt-tipped
Do a drawing of a branch using broad and narrow felt-tipped pens. Look at the shapes against the sky to see their silhouettes; do not record texture, tone or space.

Exploring brush marks
Below, a brush drawing made with the fine point of the brush to draw pen-like lines and the brush full of ink to paint quickly and broadly the darker shadow areas.

TASK 76

Artist techniques
From books and museum exhibitions, examine closely the work of famous landscape artists so that you can study the method by which they did their drawings. Be careful with reproductions, as these are often smaller than their originals, or may even have been made with different tools than those used for the original drawings.

TASK 75

Brush drawing
Take a brush, bottle of ink, small lid for putting ink into, and screw top jar of water. Go into the garden or park and do a subject drawing on strong paper.

©DIAGRAM

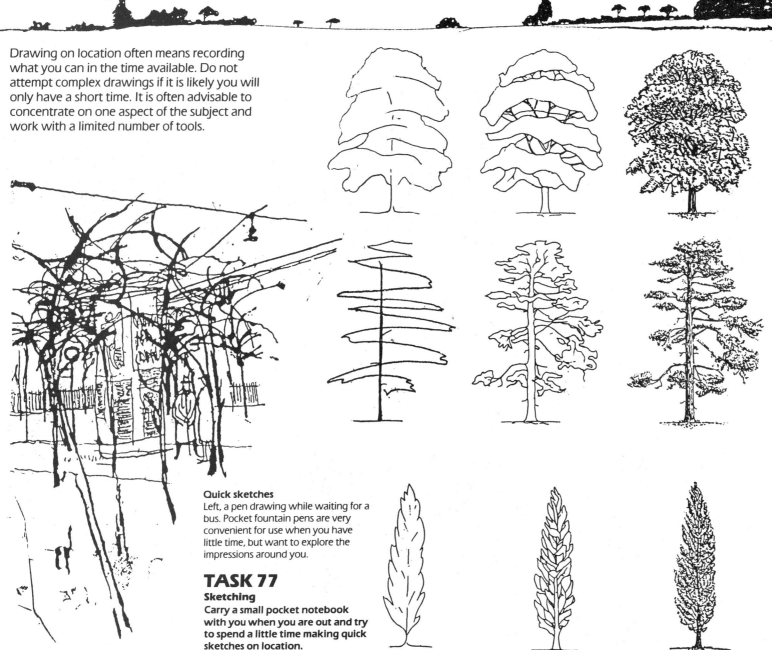

Drawing on location often means recording what you can in the time available. Do not attempt complex drawings if it is likely you will only have a short time. It is often advisable to concentrate on one aspect of the subject and work with a limited number of tools.

Remembered landscapes
Above, the silhouette of trees on distant hills greatly simplifies their form. Keep a record of horizons you pass and, on later occasions, see if you can draw these from memory.

TASK 78
Remembered detail
Draw a plant in your garden, a vase of flowers in your house, a hill or row of trees you pass frequently. Do the drawing from memory, without reference to the actual location. Then visit the scene and redraw the subject, comparing your memory study with your observations.

Seeing basics
Left, most trees conform to basic patterns, some squat, some tall. When out on location, try to grasp the overall character of the subject before you record the details.

Quick sketches
Left, a pen drawing while waiting for a bus. Pocket fountain pens are very convenient for use when you have little time, but want to explore the impressions around you.

TASK 77
Sketching
Carry a small pocket notebook with you when you are out and try to spend a little time making quick sketches on location.

TASK 79
Study drawings
Do a very lengthy study of a single view, add the maximum detail, and build the drawing from its basic elements to a complete and complex study.

Capturing light and shade
Sometimes the effect of light and shade can be more dramatic than the study of the plants that cause these effects. Try to select a composition that offers you an opportunity to treat the dark areas of ground, trees and horizon in the same manner. Do not include details of textures, tones or color.

Collecting details
Right, tree trunks make excellent subjects to study. Some have vertical markings, others horizontal and others irregular.

TASK 81
Collecting details
Keep a notebook of different types of tree trunk textures. Learn how these indicate the various species.

Completing a study
Far right, old trees like these are an excellent subject that repay long and close attention. On occasion spend more than one hour on the same drawing, adding as much information as you possibly can.

TASK 80
Shadow drawing
Sit in the sunshine in a grove of trees and draw only the shadows. Half squint at the subject to reduce it to areas of strong light and dark shade.

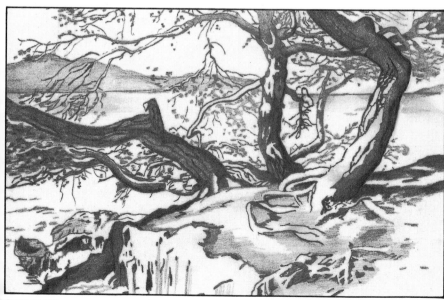

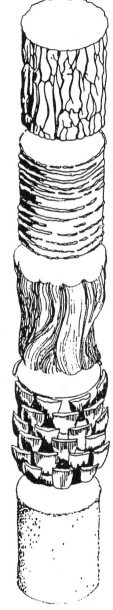

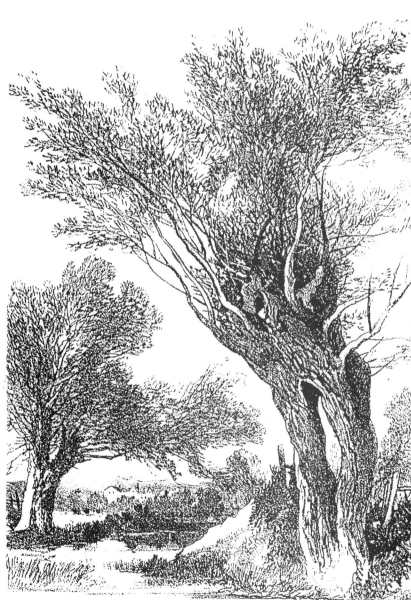

©DIAGRAM

Mastering tools
This chapter directed your attention to the tools you use and your working methods. If you practice regularly, you will find that your personal preferences for tools and surfaces form a unique and individual handwriting style.

TASK 82
Travel kit
Equip yourself with some basic outdoor tools:
1. A shoulder bag, which will be very useful for carrying all the equipment and, if worn while working, leaves your hands free.
2. A small box for pencils and pens.
3. A toothbrush box for charcoal, chalks or crayons (or to store your brushes).
4. A small box for erasers, sanding block to sharpen your pencils, clips and other small items.

TASK 83
Tool kit
Sort out all your tools, making sure you have a clean and object-free work area on a desk or table. Store all drawings away to prevent them from being damaged.

TASK 84
Drawing surfaces
Make a collection, to which you regularly add, of different surfaced drawing papers. This collection is more valuable when you have the opportunity to explore the graphic qualities of a Task.

TASK 85
Self-pride
Store all your drawings, both the Task studies and other drawings you have done. Keep them in a portfolio or store horizontally in a flat drawer. Do not fold or roll them.

CONSIDERING DESIGN CHAPTER 4

Drawing from nature means observing shapes that are the result of the forces of life. Plants grow – their leaves, stems, flowers, branches, outlines and seasonal changes are all natural expressions of living organisms. These fleeting changes must be searched out and captured. Your observational drawings and your later conversions of these to patterns must contain this vital feeling of life.

Thirty-six Tasks explain how you can convert the knowledge gained by your drawing and observations into the decorative arts. Make your drawing a thing of beauty.

● The chapter begins with four pages, 48 to 51, containing advice about what you draw. Beginners feel lost with the immense choice of subject matter. How you select a subject, the area you choose, and the treatment you apply to the selection are all factors influencing the results.
● The next two pages, 52 and 53, contain compositional considerations – how you view the subject within the picture area.

● Pages 54 and 55 look at examples of the different styles of drawing, and how a drawing's qualities are the results of the artist's character, experience, origins and tools.
● The eight pages, 56 to 63, set out fifteen Tasks which enable you to transform your early studies into patterns and designs that have many applications. The decorative possibilities of your drawings are looked at.
● Finally, page 64 invites you to enjoy drawing and learn to appreciate the beauty of flowers and trees.

When first beginning indoor plant studies, beginners find the choice of subject is one that inhibits their selection. What do you draw? Always choose simple subjects. Always choose backgrounds that do not intrude on the plants. Concern yourself with only one aspect of the subject – its silhouette, form, life, texture, colors, tones. To be able to include all the qualities of a subject in one drawing requires experience.

A single plant
One species in one container with a simple form and texture – this is the best way to begin drawing.

Unusual subjects
These dead and dried-up plants offer interesting silhouettes. Their shapes are easier to study and capture than the elusive life forces of growing plants.

TASK 86
Photographic sources
Use indoor gardening books, seed catalogs and magazines to give you ideas about the types of plants you would like to have in your home to draw.

Containers
Including containers with polished surfaces or ornate shapes can help enhance a group of plants.

TASK 87
Flower arrangements
Select seasonal flowers and arrange them in an interesting composition. The styles of flower-arranging depend upon your sense of taste. Consult flower-arranging books and keep a lookout for interesting arrangements in the home of your friends.

TASK 88
Motivation
Decide why you want to do the drawing. Find out what you think the subject offers, and work toward capturing your intentions.

TASK 89
Containers
Collect interesting containers for your flower arrangements.

It seems even harder to select a subject when out of doors than when viewing single objects at home. The trees and plants offer such a wide choice of picture material and you have often many positions to view them. Always be guided by what you think you can accomplish in the time available. Do not begin by selecting complicated studies. Begin with a compositional sketch, if selecting a group of trees. Then, after doing a study which may last two hours, do a five-minute sketch of the subject.

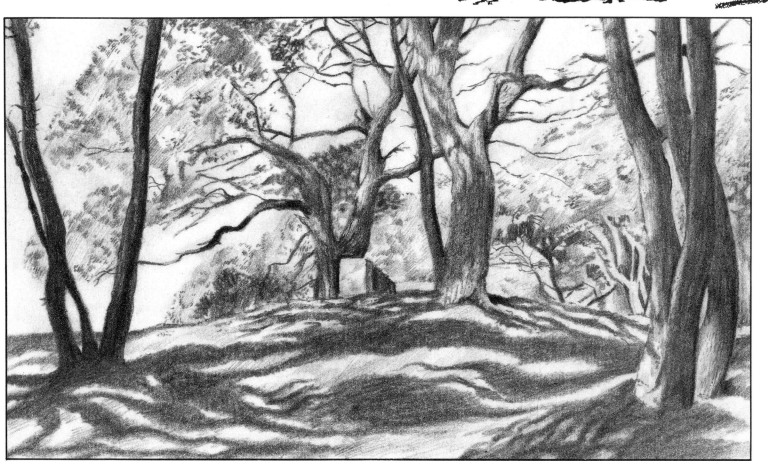

Where do you stand?
When in doubt as to the position you should take up when viewing the subject, do a series of quick sketches from several points of view. The three drawings above are the same group from different sides. Beginners should stand in front of a group and select the simplest compositions.

TASK 90
Standpoint
Draw a group of trees from a variety of positions. Try to select a group on a small hill, or separated from others, as this helps you see the shapes.

What do you see?
Left, concentrate your efforts on selecting and recording only one aspect of a subject. This drawing is an examination of sunlight and patterns of shade on a group of trees.

©DIAGRAM

What do you find?
Right, because undergrowth is usually a tangle, and individual plants often mixed with one another, individual shapes and subjects are hard to distinguish. This drawing was obtained by placing a handkerchief over the surrounding foliage and isolating the one small species.

TASK 91

Selecting features
Before beginning a study, consider looking for one aspect in the subject. You could look for plants that offer:
A good selection of textures.
A good selection of light and dark patterns.
A good selection of interesting shapes.
A good selection of forms – some old and worn, some fresh and young.

What can you invent?
Above, thinking imaginatively about what you see can offer surprising results. This sketch is of the reflections and surviving stalks of winter pond plants.

TASK 92

Species studies
On a sunny day take with you a white sheet approximately 2ft x 2ft (61cm)square and place it behind a very small and interesting plant. This shows up the tiny leaves and enables you to do a more careful study.

What can you reveal?
Right, among the tangle of natural forms, those that appear against backgrounds that isolate their shapes can be exciting. This study of hanging creepers was observed against the clearness of a sky. Studying them from the other side would have been a very difficult task as they were tangled with other plants.

TASK 93

Pattern studies
Look for the shadows of plants or their silhouettes against the sky or wall. Collect examples of interesting foliage shapes.

The design or format of your picture creates an effect on your drawing. The edges influence the elements within the picture. What you choose to select of the subject, and your position in viewing it, combine to create a composition. Before beginning a drawing, consider where you should sit and which part of the subject you should illustrate. Each drawing has three main features: its size on the page area, its position within the area; and the spatial relationships that result from your point of view.

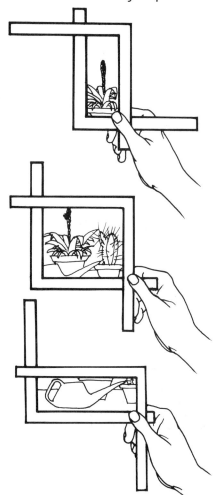

TASK 94

Viewing frame

Make two L-shaped cards which enable you to make a variable rectangular frame. Change the frame size several times while looking at the same subject and choose some of the framed compositions to make a series of small general sketches.

TASK 95

Compositional variations

Using an early study, do a series of sketches, each time placing the drawing in a different position within the same frame shape.

1. Keep the drawing small and in the middle.

2. Make the drawing large and in the middle.

3. Make the drawing small with a lot of base ground area.

4. Make the drawing large with a lot of background area.

5. Explore a number of possible sizes and locations with the same frame area.

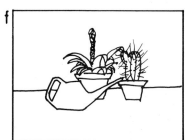
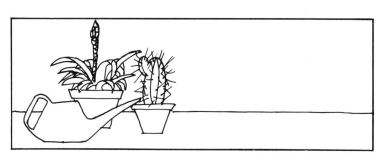

The view

Always try to select a direct view of the plants (**a**). Often drawings fail to convince because of the complexity of the view (**b**). Sitting viewing the subject straight ahead is a good way to begin a study.

The size

Normally draw the subject with enough space around it (**c**) to enable you to mount a frame, selecting the position and area at a later date. Drawings which are large and fill the total area of the page (**d**) make later framing difficult.

The position

Each subject suggests its one position within the composition. Those with extremes of space (**e**) have a higher degree of tension than those located in the middle of the page (**f**).

Frame shape

Normally the paper area you draw on is rectangular and its longest side is horizontal. When considering the composition, try a variety of frame shapes, some horizontal, others vertical.

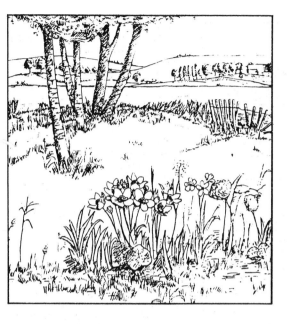

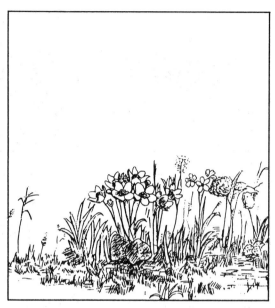

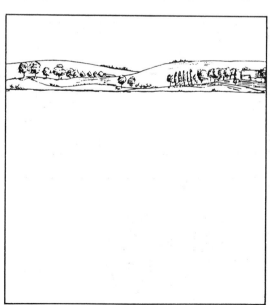

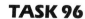

Compositional elements
Most landscape drawings are divided into three areas: the foreground, the middle distance and the far distance. Normally, the scale of the far distance creates a flat passive element. The objects within the middle distance draw the reader into the composition, and the foreground objects frame the base of the picture.

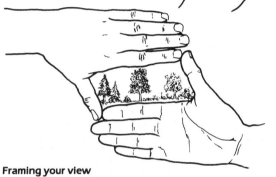

Framing your view
When on location, use your two hands to form a small rectangular frame through which to view the subject. Artists often take with them on location a cardboard frame into which is cut a small rectangle through which they view the subject. When considering landscape subjects, you could view the scene through an artist's reducing glass. This is similar to looking through the wrong end of a telescope.

TASK 96
Picture space
Do a detailed drawing of a subject that has strong elements in the foreground and passive elements in the background.

TASK 97
Artist's drawings
Make compositional sketches of drawings by famous artists of landscapes containing trees and plants.

The style of your drawing is the result of a number of independent factors. First, your cultural and historical background. Second, your experience and skill and, finally, your intentions while doing the drawing. In addition to these factors, the method of creating the drawing (the tools you use or how the drawing may be reproduced) also affects its qualities. Remember when looking at the work of other artists that, if it is a reproduction of their drawing, then it may have been originally drawn larger or with different materials than those used in the reproduction.

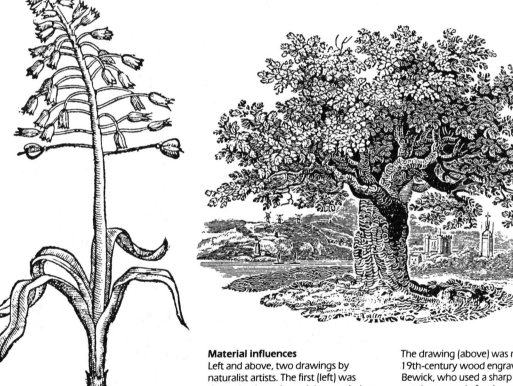

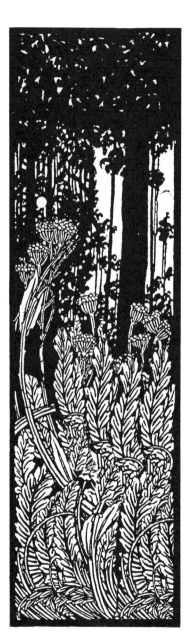

Material influences
Left and above, two drawings by naturalist artists. The first (left) was drawn by the artist and then copied on to the side of a piece of wood. The design was then carved to reveal a raised surface which was used as a printing block. This example is reproduced much smaller than the original drawing or the printed copy.

The drawing (above) was made by the 19th-century wood engraver Thomas Bewick, who used a sharp metal tool to cut the top end of a piece of very hard wood. This is printed here the same size it was carved and shows the remarkable skill of the artist.

Cultural influences
Left, a drawing by a 19th-century artist in the popular Art Nouveau style. Artists modified their way of looking at natural objects so that the resulting drawings were executed in sweeping, curved, sinuous lines.

TASK 98
Professional influences
Collect examples of reproductions by botanists and examine the ways in which information drawing presents the maximum detail.

TASK 99
Subjective responses
Look at plants and trees for opportunities to do a drawing that expresses your emotional responses to the subjects.

TASK 100
Technical influences
Collect examples of plant drawings from books published before the 20th century. The illustrations will almost certainly be engravings or lithographs and, moreover, transcriptions of drawings, not reproductions of original drawings. Learn the methods of printing illustrations so that you can recognize etchings, engravings, woodcuts and wood engravings.

Economic influences
Far left, a 20th-century architect's sketch of an intended building. His leaves and branches are inventions of the foliage – quick, cheap ways to provide visual decoration to soften the appearance of new constructions.

Traditional influences
Left, detail of a 19th-century Japanese book illustration in which the drawing of leaves and plant forms conforms to the accepted customs of the readers. Each item in the drawing is a shorthand description of formalized representations of reality.

Subjective influences
Right, a drawing by the 19th-century Dutch artist Vincent Van Gogh. Reality takes second place to Vincent's responses to the active qualities of the trees. He wants us to experience the movements of wind through foliage.

TASK 101
Cultural influences
Collect reproductions of drawings from India, China, Japan and Persia. Also, study the designs from earlier periods, such as Egyptian, Roman and Medieval.

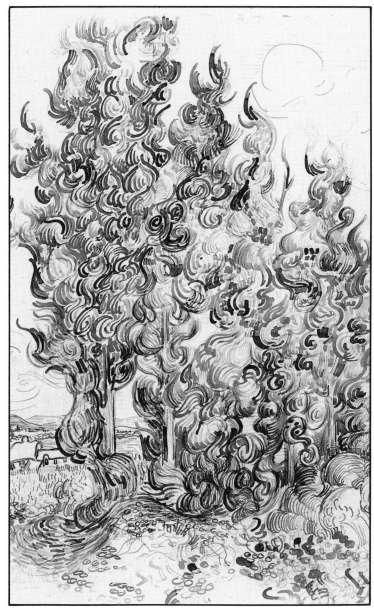

©DIAGRAM

Artists have used plants as starting points for design for more than 4000 years. The variety and aesthetic qualities of natural forms have inspired artists when they have sought to use plants as motifs for designs. Often the style of a design is the result of looking at a subject with a particular method of converting a natural form into a stylized form in mind. It is irrelevant what

subject matter is chosen as most will be capable of being converted to a formal design. There are basically three ways to achieve this: either all natural shapes are drawn as contrasting values but retain their general features; or the plant is simplified; or the drawing is formalized.

Working method
When doing the Tasks on pages 57 to 64, use only felt-tipped pens or brushes. These will automatically give you the solid areas needed in design. Pen or pencil will require laborious building up of tones.

Contrasting method
Left, a simple method of converting a drawing is to simplify shapes, objects, spaces and colors into black and white shapes.

Formalized method
Right, drawing a plant in a regular geometric manner with no regard for its living individual characteristics, the drawing becomes a representation of flowers, leaves and branches. Normally, it is constructed with lines of even thickness or on a regular grid.

Simplified method
Below, these drawings have been converted to the simplest of their elements, mainly their silhouettes with the removal of small or complex parts. There are fourteen examples at the bottom of these two pages.

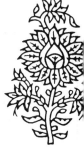
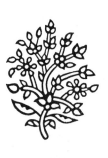
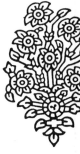

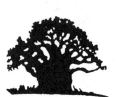

TASK 102
Contrasting designs
Reduce one of your earlier studies to an arrangement of black and white shapes. Do not change the shapes.

TASK 103
Simplified designs
Copy any earlier drawings of plants, reducing them to a simplified solution and removing any smaller details. Modify the shapes and spaces so that they have an even, balanced, overall appearance.

TASK 104
Formalized designs
The sequence of drawings (below) shows you how to transform a naturalistic study to one with a rigid, formal structure. Begin with a single study drawing and do a silhouette study of the drawing, then an outline study. When you feel you understand the basic elements, repeat the shapes on a regular grid, confining areas to within parts of the grid.

TASK 105
Alternative designs
Repeat Task 104 on a different grid arrangement.

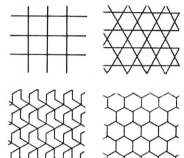

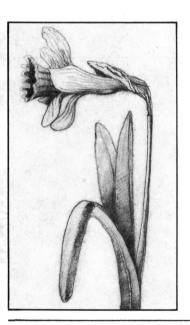

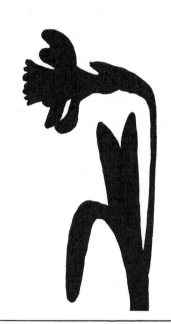

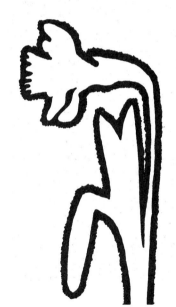

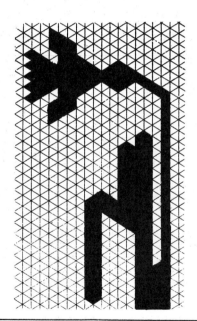

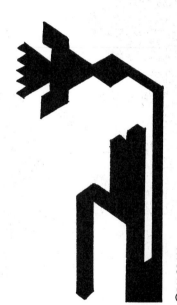

©DIAGRAM

Designs of formally arranged plants are easily developed into abstract designs where the natural shapes have been modified to produce an organized arrangement. This can be by a superimposed design technique, such as converting the drawing to a grid or to a stencil style, or by converting it to a symmetrical arrangement, or to a repeat arrangement.

Stencil method
These are designs where all the dark areas are separated by corridors of white space. This technique was originally intended as support for the stencil surface when the designs were cut to form holes. By using this design characteristic, you can achieve a unification of your drawings.

Grid method
The technique illustrated on page 57 where all the shapes are drawn within a regular grid.

TASK 108
Grid designs
Convert the design in Task 106 to a grid arrangement, using the method described on page 57.

TASK 106
Stencil designs
Convert one of your drawings to an arrangement of shapes each separated by white lines.

Symmetrical method
Left, these three drawings are symmetrical: all have a center line and mirror images of facing sections. Rarely do plants grow in a truly symmetrical way. If symmetry is combined with a fomalization of the natural elements, the shapes develop ornamental and irregular qualities.

TASK 107
Symmetrical designs
Take a section of one of your studies and convert it to a simplified solution as in Task 103. Copy half of the design on to tracing paper and, reversing the tracing paper, copy the same half on the back surface. You now have a symmetrical drawing. The same method can be used by inserting the design with a top to bottom repeat. The ultimate symmetry is for the top to mirror the bottom and the left side to mirror the right.

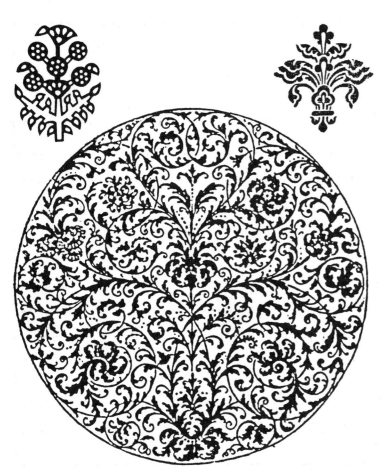

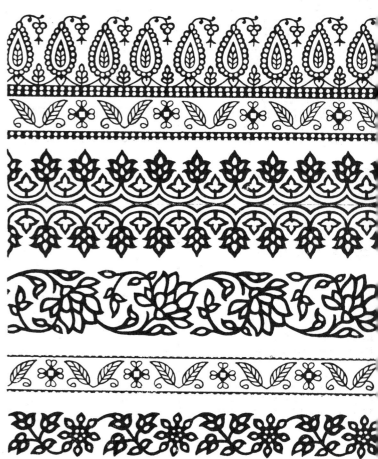

Repeat band method
Using the same design over and over in rows or all over has hundreds of variables. The simple motif can be repeated, or alternated with other subjects, or flipped left to right, or top to bottom. Whatever the solution, the pattern is obtained by an inner repeat matrix which is used by the designer to position the individual elements.

TASK 109

Repeat band designs
Using these grids, draw a selection on to tracing paper, having enlarged them to a depth of 3 in (7.6cm). Then draw one of your simplified designs in one of the structures, and vary its position by repeating, reversing, turning upside down or alternating with other designs.

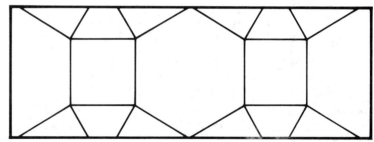

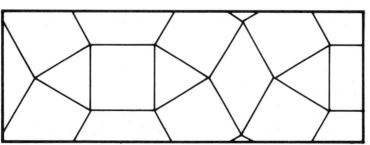

©DIAGRAM

In addition to the formalization of natural motifs and their use in repeat bands, designs can be developed to produce an overall pattern. The most successful of the overall patterns are those where the individual motifs in the pattern are secondary to the whole and are not immediately apparent. Methods of achieving overall patterns are either haphazard, repeat or hidden.

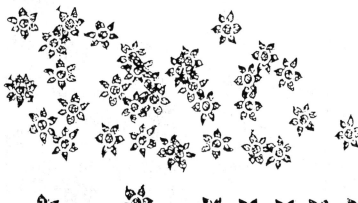

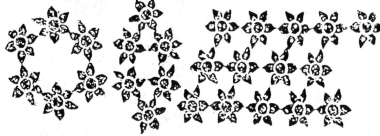

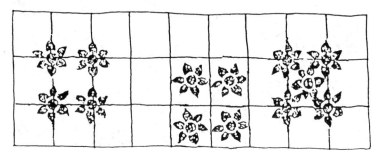

Haphazard
The scattering of a motif all over the surface may be either regular or, more often, in clustered areas of accidental groupings.

TASK 110
Haphazard
Cut a potato in half and on the exposed flat surface carve a simple plant design. Leave the areas you wish to print raised, cutting down into the potato and removing ¼ in (0.65cm) of the area you wish to have white. Press the design onto an ink pad or inked flat surface, and print a group of your designs in a haphazard arrangement (top left).

Regular patterns
Center left, these are arrangements of single motifs in a geometric structure. Usually the design is arranged with its extremities touching as this produces an overall effect of linking-up, rather than an appearance of avenues of separated white space.

Using a grid
You can plan a grouping of your designs by using a grid, which will produce a more regular arrangement (bottom left).

TASK 111
Regular patterns
Use your potato press design to print a regular arrangement of designs. Plan the grouping using any one of the grids on the right. Locate your design on the corners or in the centers or both. Experiment with other pattern arrangements.

Hidden repeats
The most satisfactory pattern solution was developed more than 2000 years ago by fabric designers. The basic technique is to cut up and re-arrange the original design, then add motifs in the spaces created. The new design is now printed in interlocking sequence producing an overall pattern in which it is hard to detect the original single unit.

1

TASK 112
Hidden construction
Make yourself a hidden repeat design using one of your simplified plant designs from earlier Tasks.
1. Draw an accurate square around the design, leaving approximately 1 in (2.5cm) around the sides.
2. Cut your design into two sections (A/B) along a vertical irregular line.

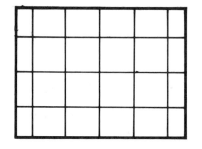

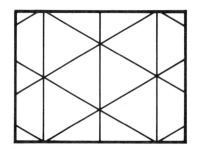

2

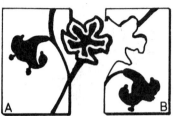

3

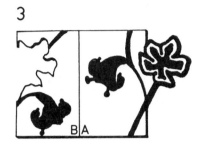

4

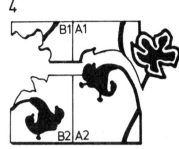

5

6

3. Transpose the two halves and fix together (B/A).
4. Cut the new arrangement into two halves along a horizontal irregular line (B1/A1 and B2/A2).
5. Transpose and join these (B2/A2/B1/A1).
At this point, the four external corners of the original square should now be meeting in a central point.

6. Fill in the newly created spaces with further motifs resembling those of the first design.
7. Print the newly constructed master design in a repeat form, ensuring that the edges of each printing match up together.
The repeat design contains sections of the original design and when combined in printing, re-establishes the original design.

TASK 113
Hidden Repeats
Look carefully at wallpapers and fabrics to try to discover which part contains the basic repeat design.

7

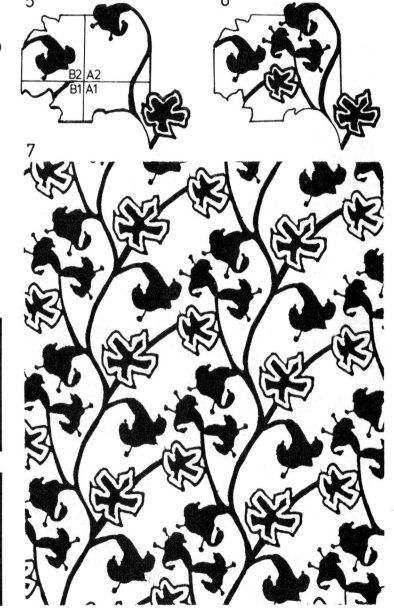

The study of plants and their application in the decorative arts has been an artistic preoccupation for over 2000 years. Before the 17th century, methods of reproducing factual visual studies were very limited, so the decorative interpretations were more common. Recent advances in photographic reproduction techniques have made artists' original studies more available.

TASK 114
Botanical knowledge

Right, this 19th-century decorative panel combines a wide variety of different plant species. Although you may not be able to name the species, try to do a drawing of each of them by selecting the leaf or flower shapes.

TASK 115
Botanical study

Select either a wild or domestic flower. Take care to choose a flower you can study from observations. Do a series of drawings of its real, unique characteristics. Then, from books on natural history, read about its growth and form. Having studied the botanical elements, re-examine your plant, this time observing how the scientific explanations are different from the reality.

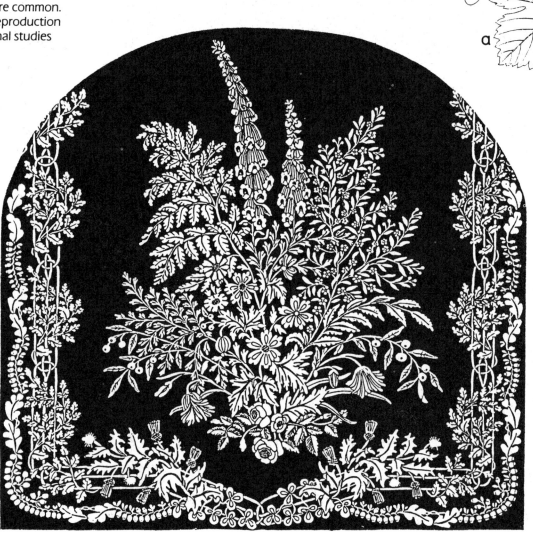

The vine

Above and opposite, a collection of designers' interpretations of one species. The vine has three main characteristics: the leaf shape (**a**); the fruit (**b**); and the curling stems (**c**). Each of these artists has organized the elements in a variety of ways. These adaptations are the consequence of their culture, the materials used, the tools employed and the intention of the decoration. Although reproduced here in different sizes to the originals, try to identify approximately which civilization the artist lived in, for what purpose was the motif created, and how the design was produced?

TASK 116
Applications

Visit a museum of decorative arts or folk arts, or a grand house open to the public and make notes when you see floral designs on domestic objects.

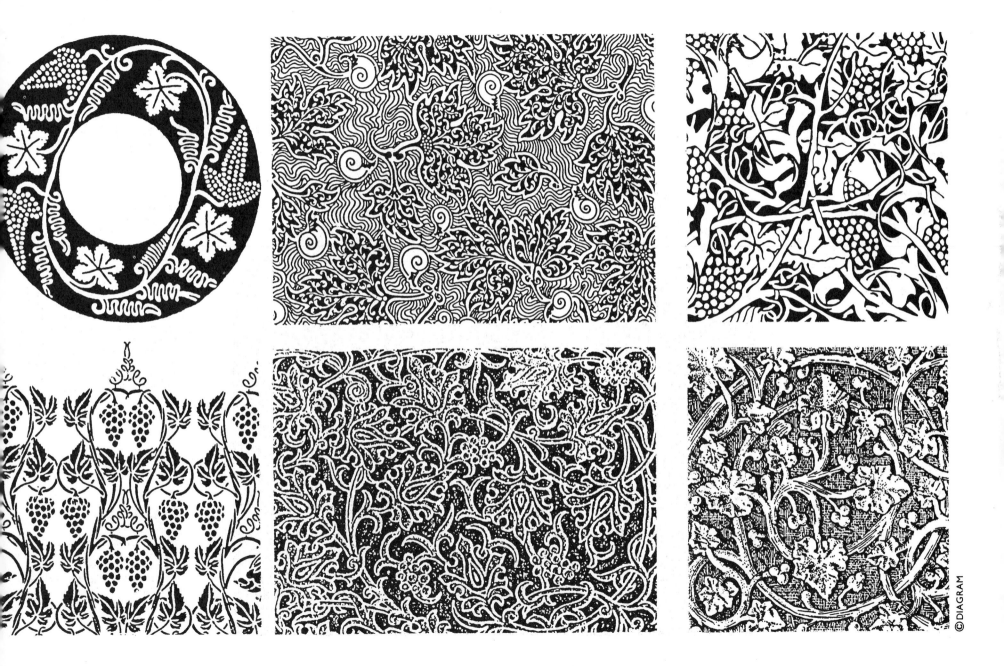

Your achievements
After more than 100 Tasks directing you to the study of plants and trees, your portfolio should now reveal evidence of the knowledge you have gained in looking carefully at natural forms. You should also have learned how difficult it is to capture the sense of life in nature. Remember that each of your drawings commits an observation to your memory, FOREVER. Each drawing is a development of earlier attempts. Remember, too, that however difficult you may find the subject, the results of effort always show in the sense of achievement you feel when successful. Always work hard and always have pride in your work. Drawing plants is very, very difficult, but can be great fun when you present a successful drawing to your friends.

TASK 117
Artistic variety
Collect examples from every possible visual source of one species. You may perhaps choose an oak, a tulip, a palm tree. Build a scrap book of cuttings from magazines, your own sketches of decorations, or depictions on buildings, fabrics, ornaments, emblems, flags or any other applications of the variety of plant you choose.

TASK 118
Application
Make your own greetings or gift card, either by a home printing technique or professionally printed. Before converting your original drawing for commercial printing techniques, discuss with the printer the costs and methods of preparing the drawing. Print enough copies for all your needs, but retain one example forever in your files.

TASK 119
Pride
Select your very best study. Spend money on having it professionally mounted and framed. Display it in your home.

TASK 120
Original drawings
Right, a beautiful pencil study by the 16th-century German artist, Albrecht Dürer. Before photography, reproductions of drawings of this type of study were very difficult and so rarely seen by a majority of people. Try to examine original drawings in museums and galleries, and when you see reproductions, consider the ways in which they differ from the original drawings. This is a reproduction in black and white of Dürer's colored study.

TASK 121
Pleasure
Regularly buy cut flowers and make arrangements at home. Cultivate indoor and outdoor, plants as these can be a great comfort during times of stress. Remember, although all plants appear to die, nature is eternal and will always offer you pleasure without asking for a reward or thanks.